Images of America
Tennessee State Capitol

On the Cover: Taken on March 18, 1941, this image shows Nashville's Armistice Day Parade. Thousands of people crowd along Capitol Boulevard to watch veterans pass in front of the south side of the capitol and the War Memorial Building as four airplanes fly over. The Tennessee State Capitol is not only one of the nation's most historic buildings, it is also a place where generations of Tennesseans have gathered. (Courtesy of the Nashville Public Library, Metro Nashville Archives.)

IMAGES
of America
TENNESSEE STATE CAPITOL

Jeff Sellers
Tennessee State Museum

ARCADIA
PUBLISHING

Copyright © 2024 by Jeff Sellers and the Tennessee State Museum
ISBN 978-1-4671-6189-3

Published by Arcadia Publishing
Charleston, South Carolina

Printed in the United States of America

Library of Congress Control Number: 2024938616

For all general information, please contact Arcadia Publishing:
Telephone 843-853-2070
Fax 843-853-0044
E-mail sales@arcadiapublishing.com

Visit us on the Internet at www.arcadiapublishing.com

To the people past and present who have worked to preserve and promote the history of the Tennessee State Capitol

Contents

Acknowledgments		6
Introduction		7
1.	Design and Construction	9
2.	The Civil War Years	21
3.	Capitol Interiors	35
4.	The Capitol Grounds	49
5.	Preservation and Restoration	65
6.	The Capitol Hill Neighborhood	83
7.	The People's House	107

Acknowledgments

Much like the capitol itself, this book has been many years in the making and is the result of many people's hard work. Over 10 years ago, I wrote a proposal for this book. Although other projects took precedent, the desire for a photographic history of the building never went away. Now that it is complete, there are so many people to thank. Without their help, this book would not be possible.

First and foremost, thank you to my wonderful colleagues at the Tennessee State Museum, specifically to our executive director, Ashley Howell, who saw the value in this book from the first day we discussed it. Our editorial committee at the museum—Joe Pagetta, Richard White, Christopher Grisham, and Dr. Miranda Fraley-Rhodes—meticulously proofed, edited, and reviewed the content. Larry Dahl worked hard finding and digitizing images from the Tennessee State Museum's collection. Lacey Morris collected and organized the dizzying amounts of images coming from several archives and collections.

I am thankful to the amazing archivists throughout the state. Both the guest services team and the digital services team at the Tennessee State Library and Archives were so helpful and extremely efficient in compiling the large amounts of images pulled from many different collections. Laura Scott at the Nashville Public Library Special Collections took special interest in the project and was so helpful in finding unpublished images. Director Ken Fieth and Grace Hulme at the Metro Nashville Archives were both wonderful to work with and so very helpful in making their images accessible. Each of these three repositories are incredibly valuable to our state's history. The professionals that work there are dedicated to assisting with the preservation and promotion of it every day.

Special gratitude goes to my capitol mentor, Jim Hoobler. He has taught me that you must not only learn the building's history, but to truly care for it, you must fall in love with it and dedicate years of yourself to it. No one has done a better job of caring for and promoting its history than him in his many years as curator of the capitol. Lastly, I could never have completed this project without the friendship and constant support of my lifelong friend, colleague, and wife, Dr. Tammy Sellers. Years ago, we met in graduate school in what I like to call a "match made in history" (to which she inevitably groans at the dad joke). She is not only my wife but my most trusted colleague, an amazing historian who reads every word that I ever write for a public audience. And finally, to my two amazing children, Allison and Harrison, whose love and laughter inspires everything I do.

To each and all of you, thank you for all you have done to make this book a reality. I hope you enjoy it as much as I have enjoyed working with you.

INTRODUCTION

On July 4, 1845, an immense crowd gathered atop the highest hill in downtown Nashville. To the locals, it had been known as Campbell's Hill after its owner, Judge George Washington Campbell. However, recently the local papers had given it a new name, Capitol Hill. It was on this day that the people of Nashville and the surrounding countryside arrived to watch the laying of the cornerstone of the new Tennessee State Capitol. Before setting it, Wilkins Tannehill, a grand master of the Freemasons, placed a time capsule underneath the giant stone. Inside two hermetically sealed jars were various objects from the year 1845, including coins, newspapers, and copies of the Declaration of Independence and the Constitution. Lastly, a scroll was carefully placed. On it read a Latin phrase, *Dum tempus fugit, hoc templum stabit*, which translates to "Though time passes, this temple will stand."

Indeed, for over 170 years, that phrase has held true. The building begun on that day and completed 14 years later has remained Tennesseans' seat of government through the generations. It has seen all that the passing of time delivers: wars, depressions, celebrations, funerals, demonstrations, debates, and compromise, but through it all, the building still stands as a temple of democracy.

In my 20 years of facilitating tours of the Tennessee State Capitol, I have never grown tired of telling its stories. Each tour is unique because each visitor is unique. I enjoy helping them find their own connection to the building through those stories. I am not sure which ones I love telling most. Perhaps it is the story of the ratification of the 19th Amendment and that fateful vote on the House floor in August 1920. It was then when Harry Burn, a noted antisuffragist, switched from his earlier votes and voted "aye" for women's suffrage. Why? Mostly on the advice of his mother (the most influential person in any young man's life). Maybe it is the story of William Driver. When the capitol fell to the Union army in 1862, he offered "Old Glory," his nickname for his beloved American flag, to fly over the building. Maybe it is the fact that the building's architect and chief commissioner both cherished the building so much that they were honored with burial within its walls. Maybe it is reminding people of the many less known individuals, from enslaved laborers and convicts to stonemasons and porters, who contributed to the building's beauty and significance.

Perhaps my very favorite moment in a tour is standing in front of a group of students before we even begin. Their eyes are full of excitement. Before we go inside, I invite them to take a second and soak in the moment, to look at the huge, beautiful building in front of them. "Look at the massive columns," I say. "Look at the tall tower with the flags flying proudly on top." Then I ask them, "Who do you think owns it?" One brave child may say, "The president?" I surprise them with my reply. "You! You own it!" They can't believe it. "Yes," I add, "you are part owner of this beautiful building. You have a stake in its history, its beauty, its past, its present, and most importantly its future." Lastly, I will ask, "Do you think it is important to learn about what has happened here and what continues to happen here even today?" "Yes," they all say. "Let's all go in together and learn about this beautiful treasure that we all own as Tennesseans." At this point, they cannot be contained any longer, and it is time to explore.

This same invitation I offer to you, dear reader. No matter who you are or where you come from, the Tennessee State Capitol building has a history that is relevant to you. The architectural community reveres it for its pure Greek Revival design. Legislators and government officials respect it because they spend weeks, months, and years inside it dedicated to working for a better Tennessee. The public sees it as the place to bring their voices and have them heard. Where will you find your connection?

Whether it is the government that happens here or the stories of those individuals who built it, maintained it, and restored it for us to enjoy, we each have a stake in its past, present, and future. More than any other building in the state, the Tennessee State Capitol embodies the people of Tennessee.

The Tennessee State Capitol—having functioned for over 170 years as Tennesseans' seat of government—stands today as one of the most historical and architecturally significant buildings in the nation. Let's go in together and discover why.

Hopefully, by reading this book, you will have the same love and appreciation for the capitol that the past generations have had and that we, the current generation, might fulfill that Latin phrase into the next generation. Though time passes, this temple will remain.

One

DESIGN AND CONSTRUCTION

The Tennessee State Capitol building has stood on the highest hill in downtown Nashville and has served as the seat of government for over 170 years. However, the state capitol of Tennessee had been in many buildings and several Tennessee towns before the location was set and construction was completed. This chapter explores those earlier seats of government and why they were not the permanent location of the state capitol. This chapter also examines the design and construction of the iconic Tennessee State Capitol building by diving into the stories of its architect, William Strickland, and its building commissioner, Samuel Dold Morgan, as well as the important contributions of stonemasons, enslaved laborers, and convict laborers. Lastly, it provides some of the earliest pre-Civil War images of the capitol through prints and paintings of the era.

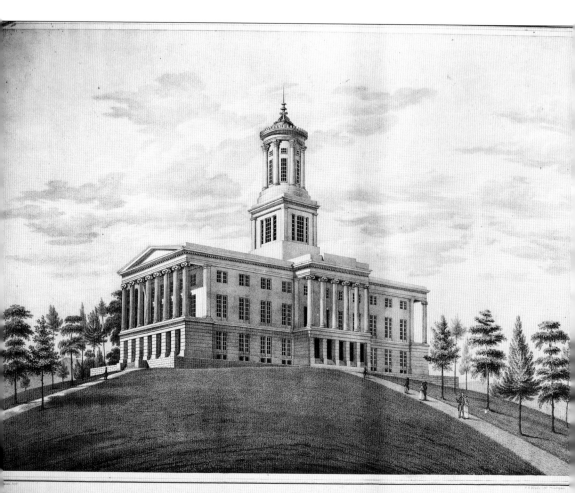

STATE CAPITOL,
NASHVILLE TENNESSEE.

P.S. Duval, a prominent lithographer, produced this likeness of William Strickland's design in the spring of 1846. It was likely fashioned from Strickland's own renderings that won him the contract to build the state capitol and is one of the earliest images of the building. It shows a design that is similar but not quite proportional to the completed building. Given the grandeur and stability, it is easy to see why Strickland's design was selected. (Courtesy of the Tennessee State Library and Archives.)

The grandeur of William Strickland's design belies the origins of Tennessee's earlier seats of government. The state is fortunate to still have two of the original sites that served as territorial capitols. The first site was Rocky Mount, begun as the home of William Cobb in 1770. Territorial governor William Blount established the capitol there outside of Piney Flats, Tennessee, until his home could be completed in Knoxville. (Courtesy of the Tennessee State Library and Archives.)

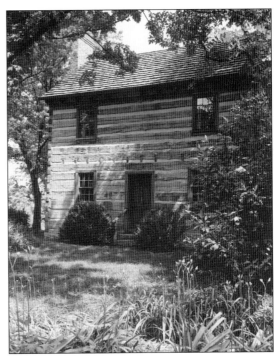

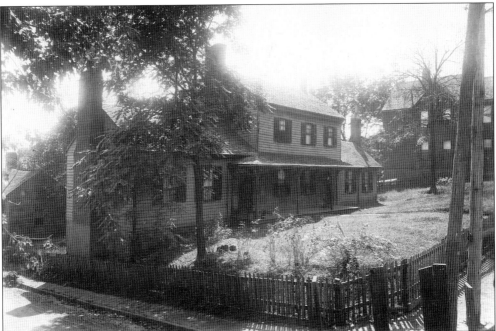

Begun in 1792 as the home of territorial governor William Blount, Blount Mansion served as the territorial capitol of Tennessee until 1796, when Tennessee achieved statehood. In 1925, Blount Mansion was in danger of demolition until the Bonny Kate Chapter of the Daughters of the American Revolution purchased the home and chartered the Blount Mansion Association (BMA). In 1930, the BMA opened the house as a museum. (Courtesy of the Nashville Public Library, Special Collections.)

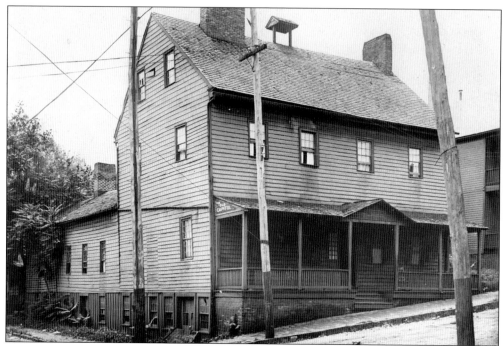

After Tennessee became a state in 1796, Knoxville served as its capital until 1812. During the early 20th century, local tradition held that this structure served as the first state capitol building. Postcard companies printed photographs with this history on the back. In recent years, historians have questioned this theory. Notice along the left side of the porch is written "The Old Capitol." Unfortunately, it was razed in 1929. (Courtesy of the Tennessee State Library and Archives.)

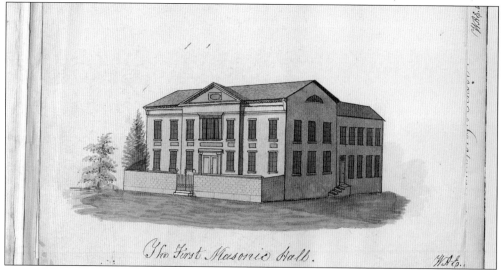

From 1827 to 1829, Nashville offered the Masonic Hall, located on Church Street between Fourth and Fifth Avenues, for use as the state capitol. The building, in addition to others, was used as the state capitol until the legislature began holding sessions in the new Davidson County Courthouse five years later. This Masonic Hall also hosted a ball for the Marquis de Lafayette on his tour of America in 1825. Unfortunately, the building burned in 1856. (Courtesy of the Nashville Public Library, Special Collections.)

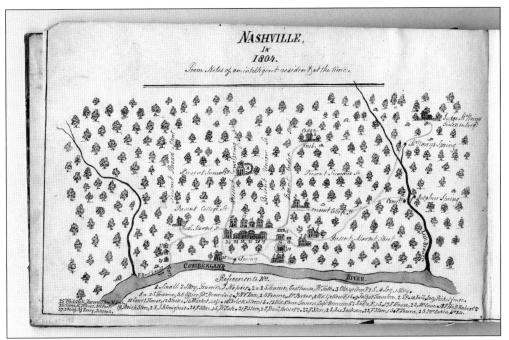

This is a map of Nashville from 1859 showing how the town looked in 1804. Notice the area labeled "Cedar Knob" located in the upper middle portion. This would be the site purchased by the City of Nashville and offered to the state for the express purpose of locating the capitol there. (Courtesy of the Nashville Public Library, Metro Nashville Archives.)

Whig governor James C. Jones played a significant role in the capitol's construction, from prodding the legislature to select a capital city to approving Strickland's final design. He served as a member of the Capitol Commission during his term as governor and then continued to hold considerable influence after he left office. (Courtesy of the Tennessee State Museum.)

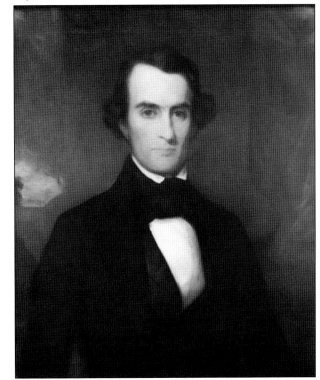

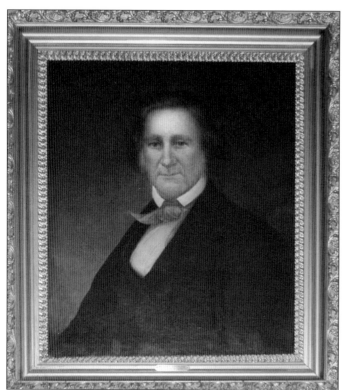

The Capitol Commission selected William Strickland as architect in the spring of 1845. Considered one of the nation's foremost Greek Revival architects, Strickland studied under Benjamin Latrobe, architect for the US Capitol, and designed some of the most beautiful buildings in Philadelphia. His design for the Tennessee State Capitol would be one of the last great monuments to Greek Revival architecture in America. This portrait was executed by Washington B. Cooper some time before 1854. (Courtesy of the Tennessee State Museum.)

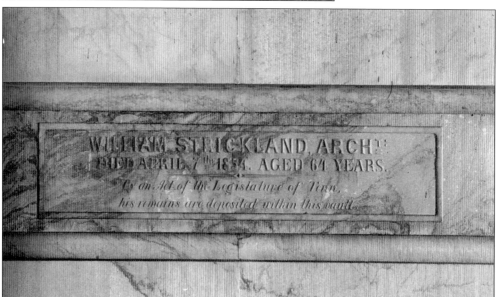

William Strickland died on April 7, 1854, without fully completing his masterpiece. A year earlier, he had designed his own tomb within the north portico (two and a half feet deep, one foot ten inches high, and eight feet six and a half inches long). Just prior to his death, the Tennessee General Assembly authorized his interment there. Funeral services were held in the House of Representatives Chamber with reports of two or three thousand in attendance. (Courtesy of the Tennessee State Library and Archives.)

In early 1844, Samuel Morgan was named one of the six commissioners for the project. He was elevated to chairman of the commission 10 years later and became the only commissioner who served through the entire project. After Strickland's death, Morgan worked closely with Strickland's son Francis, who was appointed superintendent. When Francis was dismissed, Morgan assumed the role of superintendent and hired local architect Harvey M. Akeroyd to complete the state library. (Courtesy of the Tennessee State Museum.)

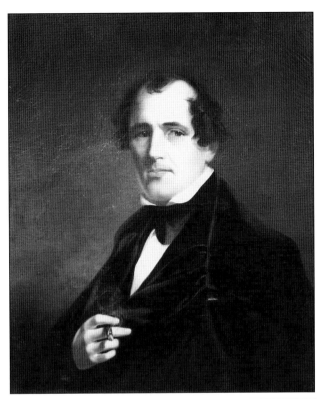

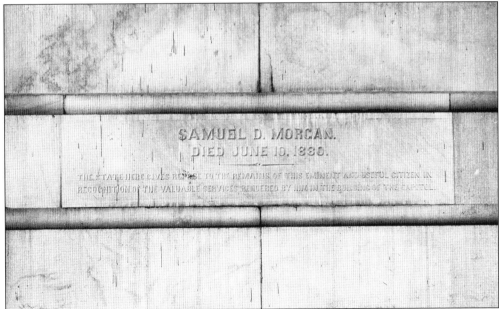

Upon Morgan's death in 1880, the Tennessee General Assembly passed an act granting his remains to be interred in a niche at the capitol. At noon on December 24, 1881, the House and Senate both adjourned so that members could attend the ceremony. A great crowd was on hand to hear eulogies, and Gov. Alvin Hawkins delivered a speech expressing the state's appreciation for all Morgan had done for the capitol. (Courtesy of the Tennessee State Library and Archives.)

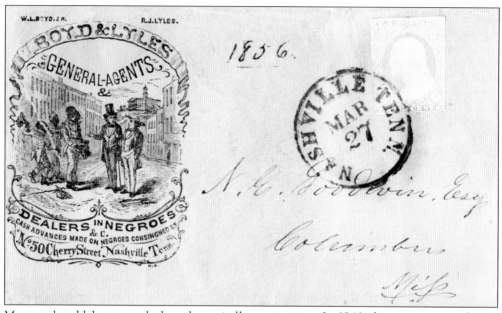

Many enslaved laborers worked on the capitol's construction. In 1846, the state contracted A.G. Payne for the sum of $8,000. This contract included the hiring out of 15 enslaved laborers to excavate the foundation. Additionally, 20 or 30 more enslaved laborers were placed at the stone quarries in 1847–1848. This envelope from 1856 contains an advertisement for slave dealers on today's Fourth Avenue in downtown Nashville. Notice the capitol in the background. (Courtesy of the Tennessee State Museum.)

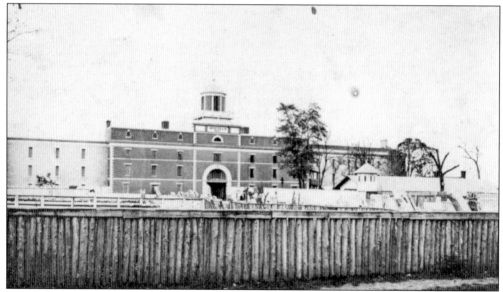

This Civil War–era photograph shows the Tennessee State Penitentiary. It was here that state prisoners prepared the quarried stone for transport to Capitol Hill. From the outset, use of convict labor was controversial. Many free laborers felt it prevented them from working on such a lucrative project. However, convict labor won out as a cost-saving measure. Both convict laborers and enslaved laborers worked on the Tennessee State Capitol. (Courtesy of the Tennessee State Museum.)

Strickland designed the capitol to be purely Greek Revival. In his proposal to the commissioners, he stated, "The architecture . . . consists of a Doric basement, four Ionic Porticos . . . surmounted by a Corinthian Tower in the center of the roof. The Porticos are after the order of the Erectheum." Upon its completion, the building's dimensions stood 238 feet by 109 feet. This detailed drawing was done as a part of the Historic American Buildings Survey conducted in 1934. (Courtesy of the Library of Congress.)

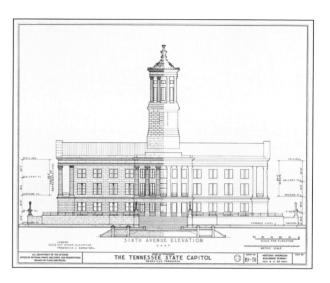

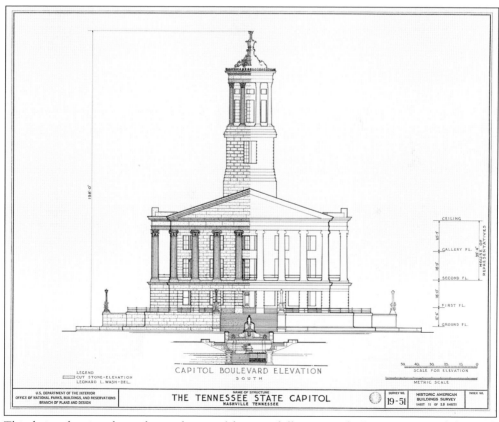

This design drawing shows the south view of the capitol illustrating the Ionic portico and the south approach from Capitol Boulevard. (Courtesy of the Library of Congress.)

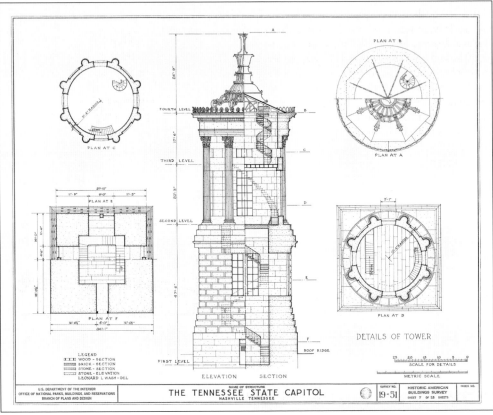

The capitol tower is one of the most distinctive features of Strickland's design and probably the most notable element constructed under Francis Strickland's supervision. William Strickland executed this design earlier in his career with Philadelphia's Merchants Exchange Building (1834). Tennessee's tower is much larger, rising 42 feet high and supporting a lantern or cupola that is 37 feet high. Crowning the top is a tripod trophy awarded to Lysicrates, who was the leader of a choir in ancient Greece. The entire tower is accessed by three flights of iron spiral staircases. (Both, courtesy of the Library of Congress.)

This early-20th-century postcard shows the Choragic Monument of Lysicrates in Athens, Greece. Erected in 335 BC, the monument was an award given to a chorus (choragic) leader during the competition of Dionysia. Strickland would not know that his adopted city would someday be known as Music City and that his choral monument would fit so nicely with Nashville's brand. (Author's collection.)

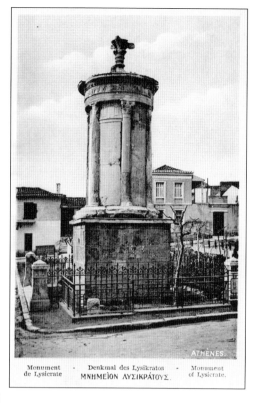

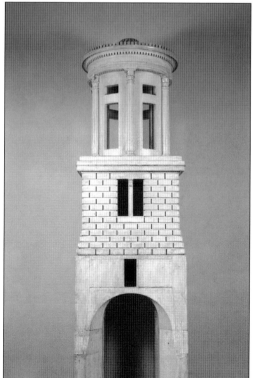

This capitol tower model stands nearly 12 feet high and is made of pine. It was possibly commissioned by Francis Strickland, who was appointed superintendent after his father died. It is believed that this rendering was made around 1853 by the local T.M. Brennan Foundry, which cast the ornamental iron finials that crown the tower. (Courtesy of the Tennessee State Museum.)

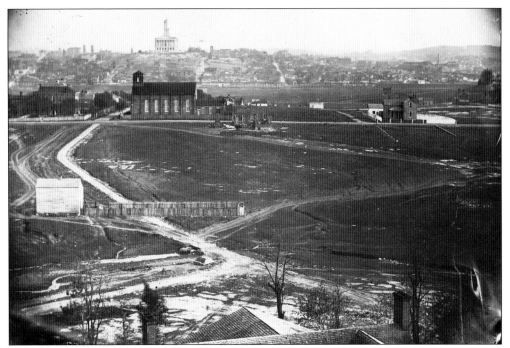

This Civil War-era photograph best illustrates Capitol Hill and how prominently Strickland's building could be seen from miles away. In the middle distance is the Church of the Assumption. Bricks from Holy Rosary Cathedral, which was razed to make way for the capitol, were used in the construction of the church. It still stands today. (Courtesy of the Tennessee State Library and Archives.)

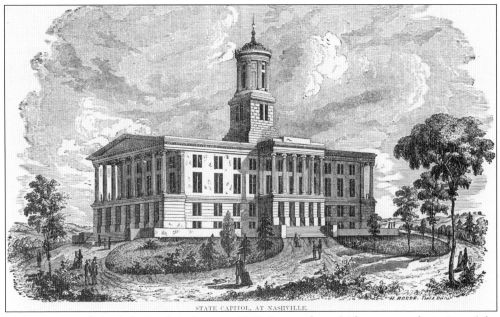

H. Bosse printed this lithograph in January 1855. It provides a fairly accurate depiction of the building with a stylized treatment of the grounds. While not fully completed, the state government first began using the capitol building in 1853. (Courtesy of the Tennessee State Museum.)

Two
THE CIVIL WAR YEARS

As the 14-year construction project ended in 1859, sectional differences between the North and South distracted from efforts to complete the grounds. Only two years later, the capitol became the center of secession debates as the governor, legislators, and voters deliberated on this critical issue. On June 8, 1861, Tennessee became the last Southern state to secede and to officially remove the US flag from atop its capitol.

Less than a year later, on February 25, 1862, the capitol became the first Confederate capitol to fall to the Union army. On that fateful day, Nashville Unionist William Driver offered his large ship's flag he had named Old Glory to the commanding officer, thus coining the flag's sobriquet that remains today. Once occupied, the capitol was quickly transformed from a beautiful building into a fort with earthworks, soldiers' tents, and wooden stockades. Black Tennesseans seeking their freedom from slavery were impressed to dig the earthworks, cut logs, and fortify the building. During the bloody aftermath of the Battle of Stones River, the capitol was used as a hospital to treat convalescing troops.

Fortunately for the capitol (and this book), the building was completed at a time when photography was becoming more common, and the Civil War brought many photographers to the city. Naturally, the new capitol became a popular subject. The most important of these wartime photographers was George Barnard. Contracted by the federal government to document federal military installations, Barnard captured some of the best and earliest photographs of the capitol. These images and others related to the Civil War and Reconstruction will be featured in this chapter and help tell the story of this tumultuous era in the early life of the capitol.

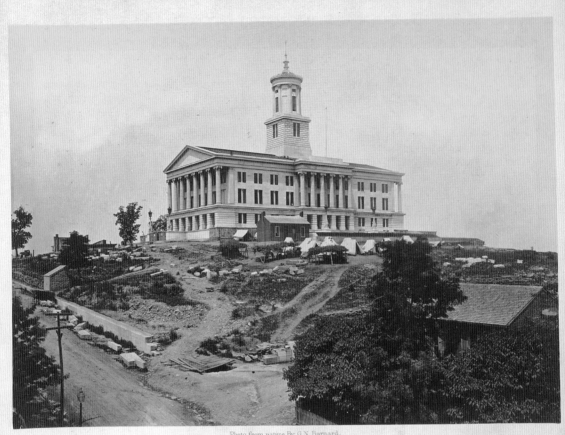

THE CAPITOL NASHVILLE. (TENN)

This photograph was taken by George Barnard around 1864. Union army tent encampments are visible on the east lawn. The small brick building was one of George Washington Campbell's outbuildings that later served as William Strickland's office. Cedar Street (today Dr. MLK Jr. Boulevard) can be seen in the lower left corner. (Courtesy of the Tennessee State Museum.)

After other Southern states seceded, pro-secession governor Isham Harris called the Tennessee General Assembly to the capitol for a special session that resulted in a statewide referendum on secession. Tennesseans roundly rejected it. After the firing on Fort Sumter, Harris called another session, where he implored: "I respectfully suggest that our connection with the Federal Union be formally annulled." This time, on June 8, 1861, the referendum passed. Tennessee became the final state to secede. (Courtesy of the Tennessee State Museum.)

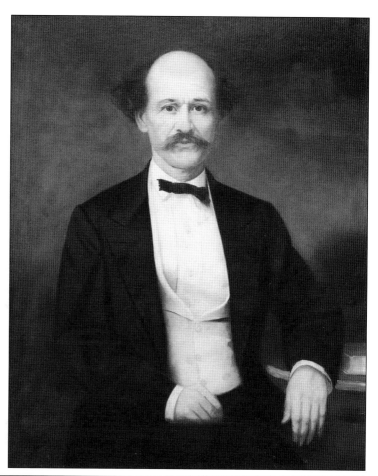

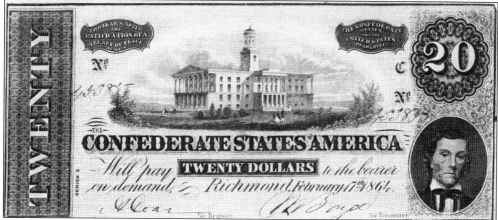

The Confederate States of America began printing this note in October 1862 that featured the Tennessee State Capitol. Ironically, the capitol had fallen to the Union army in February 1862, and that army had transformed the building into a military installation known as Fort Andrew Johnson. The Confederate government printed around 10 million of these notes. Only three state capitol buildings were featured on Confederate currency: Tennessee, Virginia, and South Carolina. (Courtesy of the Tennessee State Museum.)

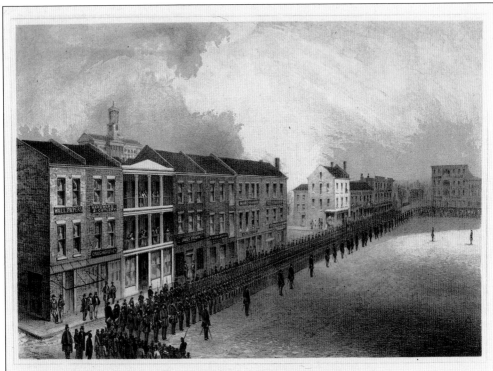

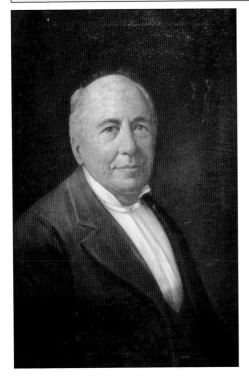

A.E. Mathews, a member of the 31st Ohio Regiment, sketched this scene and titled it "The First Union Dress Parade in Nashville." It depicts the 51st Regiment Ohio Volunteer Infantry on parade in the public square on March 4, 1862. Mathews made sure to include the newly captured Tennessee State Capitol, the first Confederate state capitol to fall to the Union army. (Courtesy of the Tennessee State Library and Archives.)

Capt. William Driver moved to Nashville in 1837 after a career as a sea captain. He brought with him his beloved ship's flag he had named Old Glory. During the Civil War and Confederate occupation, he had the flag concealed in a quilt. When the Union army took Nashville on February 25, 1862, Driver offered Old Glory to the commanding officer to fly over the state capitol. (Courtesy of the Tennessee State Museum.)

Mary Jane Driver Roland was given Old Glory by her father, Capt. William Driver, just as she was about to leave Nashville in 1873 to travel to Utah, where she would join her husband, Charles. Mary Jane and Charles settled in Wells, Nevada, where this photograph was taken around 1910. The flag was displayed on their house. (Courtesy of the Tennessee State Museum.)

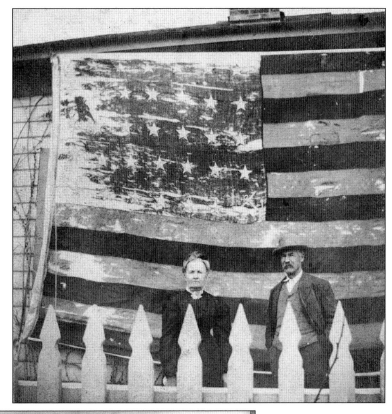

This c. 1862 sketch depicts members of the 6th Ohio Infantry, who became the first soldiers to disembark at the Nashville wharf. They marched to Capitol Hill, where they raised their regimental flag. It was then that William Driver offered his ship's flag, Old Glory. The large flag rose above the capitol for all of Nashville to see. Northern newspapers made Old Glory famous, and by the late 1800s, it became synonymous with all US flags. (Courtesy of the Tennessee State Library and Archives.)

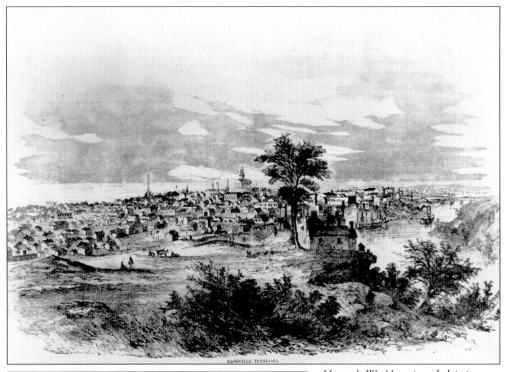

Harper's Weekly printed this image in its March 8, 1862, issue. The capitol features prominently over an idyllic illustration of the city. (Courtesy of the Tennessee State Museum.)

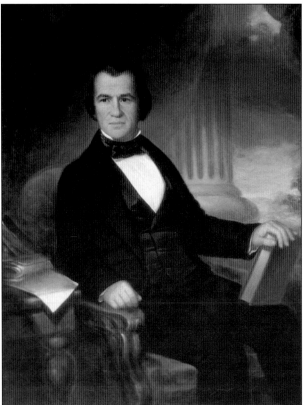

Andrew Johnson served two terms as governor of Tennessee from 1853 to 1857 and was the first to govern from the capitol building. A staunch Unionist, he was appointed by Abraham Lincoln as military governor of Tennessee in March 1862. Johnson was determined to reestablish civil government and ruled Nashville with an iron fist, arresting pro-Confederate ministers and suspending free press. In August 1862, Johnson approved the order to fortify the capitol, which gave it the informal name of Fort Andrew Johnson. (Courtesy of the Tennessee State Museum.)

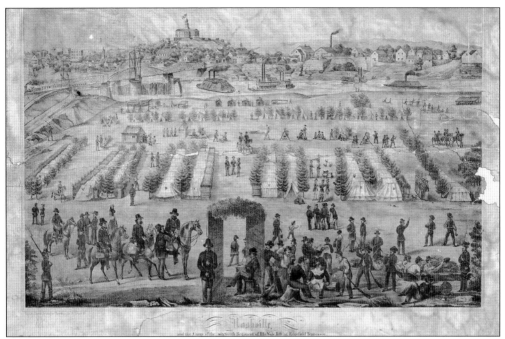

This lithograph portrays the 16th Regiment of Illinois Volunteers in camp at Edgefield (today East Nashville) and depicts a scene of occupied Nashville. In the distance, the capitol is depicted proudly waving the American flag. (Courtesy of the Tennessee State Library and Archives.)

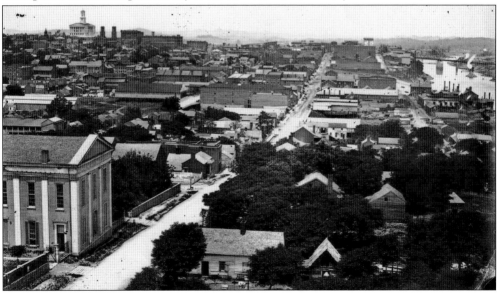

This Civil War-era photograph was likely taken atop the former University of Nashville main academic building (today a part of the Metropolitan Government of Nashville & Davidson County Howard School Office Campus). Strickland's capitol building towers over the cityscape, along with the two twin towers of his other masterpiece, the Egyptian Revival First Presbyterian Church (today Downtown Presbyterian Church). After the bloody Battle of Stones River, the Union army used every major building as a hospital, including the capitol. (Courtesy of the Tennessee State Library and Archives.)

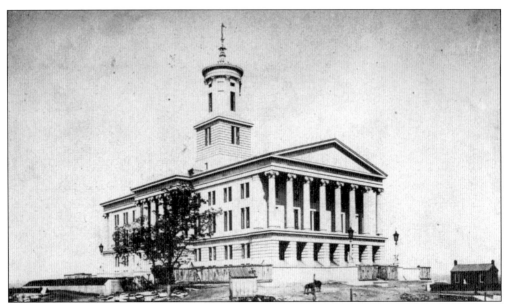

This carte de visite depicts the Union-occupied state capitol in 1863. Taken by photographer A.S. Morse, it shows the western and southern views. Morse likely set up his photography equipment on the roof of a building along Cedar Street (today Dr. MLK Jr. Boulevard) and Seventh Avenue. Notice the wooden parapets fortifying each entrance. Off to the right can be seen the original kitchen house of Judge Campbell's estate. Photographs like these were popular among Union soldiers. (Courtesy of the Tennessee State Museum.)

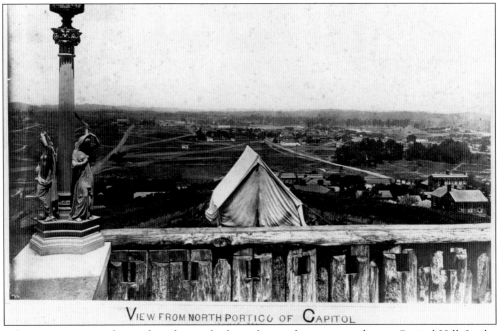

A lone tent sits atop the earthworks overlooking the northern approaches to Capitol Hill. In the foreground can be seen the huge cedar log stockades with carved openings for rifle fire. Today, this view overlooks the Bicentennial Capitol Mall State Park. During the war, soldiers used the large open plain to play the new sport of baseball. (Courtesy of the Tennessee State Museum.)

The earthen redoubt on the north slope is illustrated in this Civil War engraving. (Courtesy of the Tennessee State Museum.)

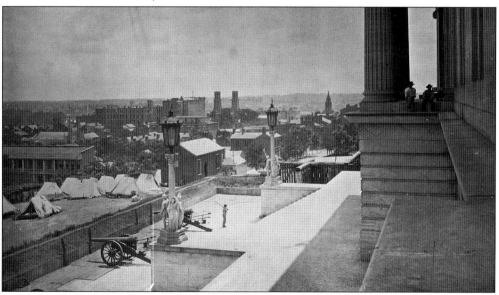

When the capitol fell to Union troops, Black laborers, seeking their freedom, were impressed into the army to build the fortifications around Nashville, including the capitol. In April 1863, Brig. Gen. James St. Clair Morton, on behalf of Maj. Gen. William Rosecrans, asked Maj. John D. Kurtz, assistant chief engineer in Washington, if they might be paid "so to support their families." Note the earthen parapet and cedar log stockades. This view is facing southeast toward downtown. (Courtesy of the Library of Congress.)

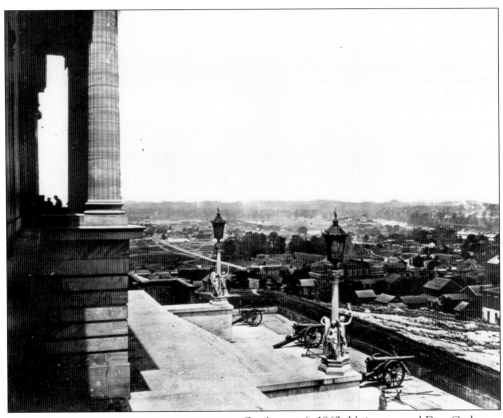

On August 6, 1862, Union general Don Carlos Buell ordered Captain St. Clair Morton, in charge of fortifying Nashville, to "devise some defenses also around the Capitol." Soon, the capitol was surrounded by earthen fortifications, stockades of cedar logs, and a battery of artillery. One military biographer described the occupied building: "Its proud Capitol, graceful and beautiful, upon the crown of a rocky hill, was a castle frowning with great guns on its battlements and bristling with glittering bayonets." (Courtesy of the Tennessee State Museum.)

Frank Leslie's Illustrated Newspaper published this view of the capitol fortifications in September 1864. The caption noted the "sad" juxtaposition of the beautiful architecture with the "grim weapons of war." The view depicts the west steps facing northwest. Notice the encampments and the train in the distance. This is likely Fort Gillem, which became a refuge for enslaved African Americans seeking freedom. After the war, this site became Fisk University. (Courtesy of the Tennessee State Library and Archives.)

Here, the photographer set up his camera along High Street (today Sixth Avenue) and captured the south and east porticoes. The capitol is well under Union occupation, with two military Sibley tents on the lawn, fortified steps, and cotton bales stacked along the terrace. Soldiers can be seen lounging on the second-floor balcony. The limestone blocks on the lawn were left from the construction of the retaining wall along Cedar Street. (Courtesy of the Tennessee State Museum.)

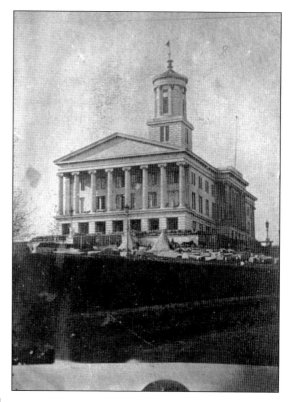

A row of tents and wooden palisades cover the grounds of the capitol in this scene from around 1864. In the foreground, the Planters Hotel and St. Mary of the Seven Sorrows Cathedral can be seen. This view was taken along what is today Deaderick Street. St. Mary's continues to sit at the foot of Capitol Hill much like it did in the 1850s. (Courtesy of the Tennessee State Museum.)

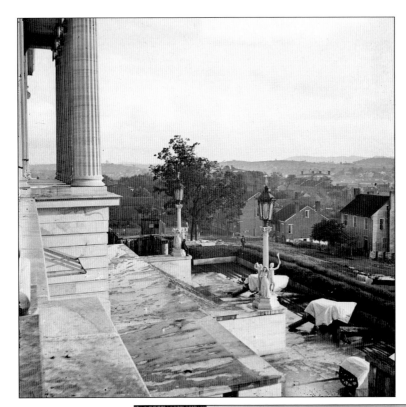

George Barnard took this photograph of the west entrance around 1864 after a rainstorm. Cannons and caissons have been covered with canvas tarps. In the far distance to the left is Fort Negley, and beyond it are the Overton hills, which today is where Radnor Lake State Park is located. (Courtesy of the Library of Congress.)

This view was taken by Union war photographer George Barnard in 1864. It depicts the south terrace steps, which have been stockaded with cedar logs. The Nashville public square can be seen in the distance. (Courtesy of the Library of Congress.)

This 1864 Barnard photograph shows the Nashville & Chattanooga railyard lined with locomotives to transport goods, supplies, and soldiers to the Union army. For many Union soldiers, the capitol was the most impressive building they had seen. One soldier wrote home, "The State House, standing on a fine mound 175 feet above the river, is the finest building I ever saw and is seen for miles around." (Courtesy of the Library of Congress.)

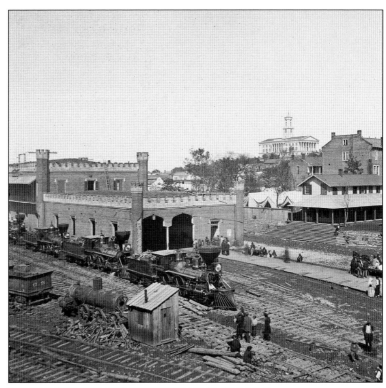

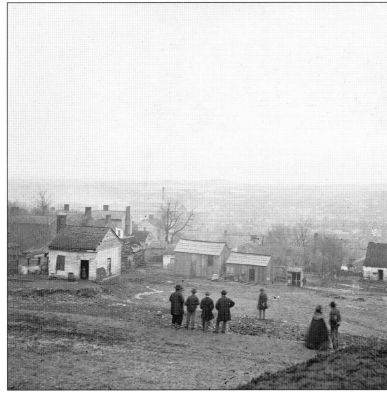

Civilians gather along the western slope of Capitol Hill in the winter of 1864 to listen during the Battle of Nashville, which took place December 15–16, 1864. Approximately 55,000 Union soldiers under the direction of Gen. George Thomas faced off against Gen. John Bell Hood's 30,000 Confederates. The Union army routed the Confederates, all but ending the war in the west. (Courtesy of the Library of Congress.)

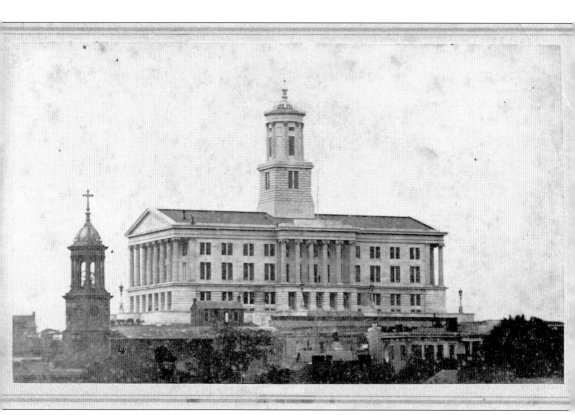

At the war's conclusion, the state legislature asked the military to remove the fortifications around the capitol. By May 1865, the fortifications were dismantled. This photograph was taken shortly after that, as the log stockades have been removed. The tower of St. Mary of the Seven Sorrows Cathedral can be seen in the foreground. (Courtesy of the Tennessee State Library and Archives.)

Three

CAPITOL INTERIORS

Each year, thousands of people tour the Tennessee State Capitol. They walk the halls, marvel at the ceilings, climb the steps, and learn the stories. The main part of the tour tells the history of the capitol's interior. From room to room, visitors learn how these spaces have evolved or remained the same over the years. While at first glance the interior retains much of its original design, the truth is that it has undergone significant changes to transform it from a 19th-century stone building to a modern 21st-century working capitol.

This chapter will take a tour of the building's interior. Just like a visitor on a guided tour, it will document each room through the years and reveal the telltale signs of how each has changed or remained the same. Beginning on the second floor, the House Chamber is the largest and most impressive space in the building. Therefore, it is no surprise that the earliest interior images capture this room. Then it moves to the Senate, where the room appears to have changed very little, even keeping the central gasolier. Next is the original state library. Designed by English architect H.M. Akeroyd, it was the last room completed in the building. It has impressed visitors throughout the generations with its cast-iron spiral staircase, frescoed ceilings, and original gasolier. Finally, the visitor moves down the grand staircase to the first floor and views the vaulted ceilings of the central corridors, the governor's office, and the lobby. Each of these areas has gone through upgrades, modernizations, and restorations that help tell the story of why this building remains so true to its original design while continuing to be one of the oldest working capitols in the country. It is a testament to the countless people who have spent their time and energy both working in this building and preserving its history.

Like the capitol itself, the interior rooms and chambers were designed not only to function as practical spaces to carry out the government of the state but also to reflect the dignity and power of the people that the government represents.

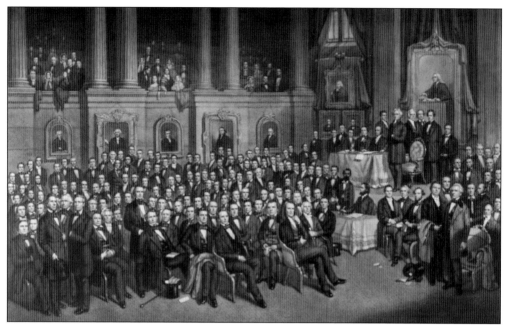

The first known image of the capitol interior depicts the delegates of the General Conference of the Methodist Episcopal Church South, which convened on May 1, 1858. George Dardis, an enslaved porter to the House of Representatives, stands at the table in the center. Dardis figured prominently in the early life of the capitol both as porter and author of an early account of the building's construction. (Courtesy of the Tennessee State Museum.)

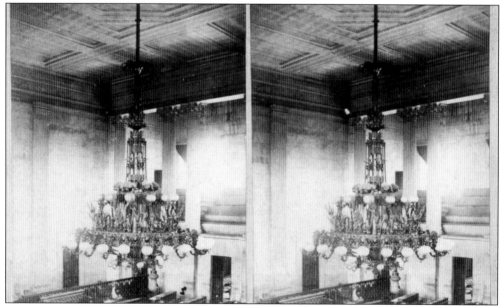

The grand bronze gasoliers, purchased from the Philadelphia light fixture company of Cornelius & Baker, were striking features of the capitol. Installed in 1855, the impressive one in the photograph hung from the ceiling in the House Chamber. Spanning 45 feet in circumference and 21 feet high with 48 natural gas burners and decorative elements of Native Americans, buffaloes, corn, tobacco, wheat, and cotton, it weighed over a ton. (Courtesy of the Tennessee State Museum.)

In 1889, this gasolier was taken down after a House member introduced a bill to remove it because he sat directly underneath it, and it made him nervous when it "swayed in the wind." The dismantling took days. Under closer examination, it appeared the gasolier was quite secure in its location and not in danger of falling. Later, the remnants of this grand gasolier were sold at public auction. (Courtesy of the Tennessee State Library and Archives.)

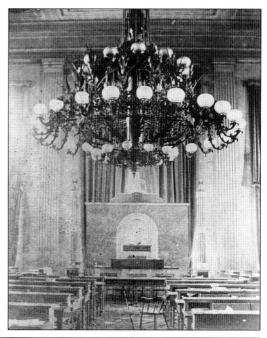

After the removal of the House gasolier, a system of small electric lights was installed. A contract was signed with the electric company to light the chamber at a cost of 50¢ per night that lights were used. As can be seen in this early-20th-century photograph, it was a far cry from the ornate gasolier but a transitional moment in electrifying the building. (Courtesy of the Tennessee State Library and Archives.)

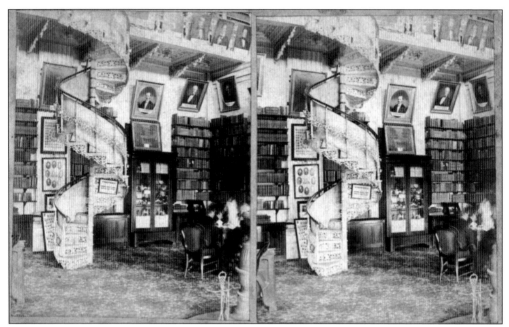

This stereoview depicts the interior of the state library in the capitol building around 1884 or 1885. This image is a part of a series of photographs titled "Views of Nashville, Tennessee and Vicinity" by noted photography studio Thuss, Koellein, and Giers. The portraits and objects in the glass cabinet belong to the Tennessee Historical Society, which housed its collection in the library for many years. (Courtesy of the Tennessee State Museum.)

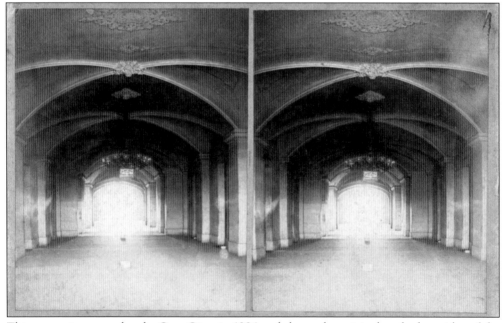

This stereoview was taken by Otto Giers in 1884 and shows the original vaulted corridor of the first floor. The sign hanging from the gasolier reads, "Do not spit on the floor or steps." To help follow this rule, a series of spittoons had been placed on the center floor and next to each door. (Courtesy of the Tennessee State Museum.)

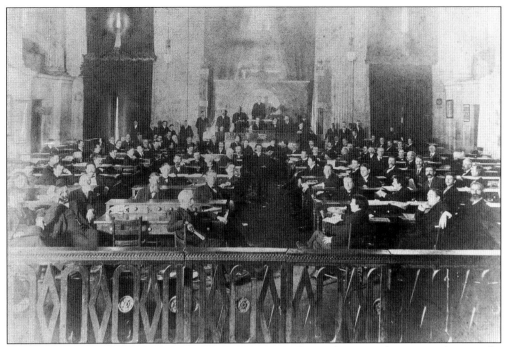

This early photograph of the House of Representatives shows the original ornate railing on the House floor and the legislators' double oak desks. A series of electric lights hangs from the ceiling. (Courtesy of the Tennessee State Library and Archives.)

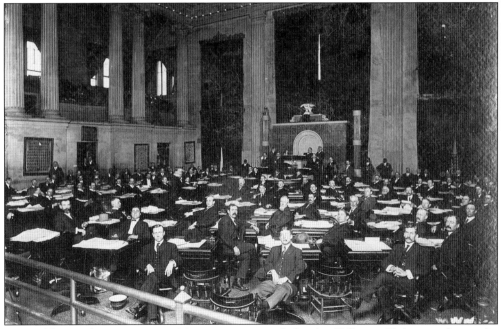

Pictured here is the 1909 House of Representatives with Speaker Hillsman Taylor presiding at the rostrum. This is a rare early view of the House members within the chamber. Notice the electric lighting strung along the perimeter of the ceiling. The metal rail in the foreground was removed in 1957. Each desk is provided with a trash can and spittoon. (Courtesy of the Tennessee State Museum.)

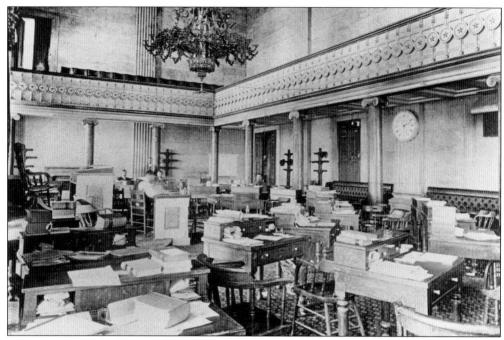

This early view of the Senate Chamber is from around the turn of the 20th century. Notice the grand gasolier gas burners have been replaced with a single light bulb hanging from the center. It also shows the original oak desks, eight-day marble clock, and long cushioned oak couches against the back wall. (Courtesy of the Tennessee State Library and Archives.)

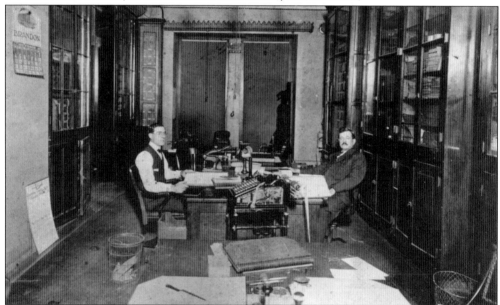

This rare photograph shows the cramped condition of the first-floor offices. Pictured here is Secretary of State R.R. Sneed's office in 1914. In 1905, Gov. James Frazier had called attention to the "congested condition" of the capitol. By the time this photograph was taken, many were calling for an annex to accommodate the growing needs of state government. (Courtesy of the Tennessee State Library and Archives.)

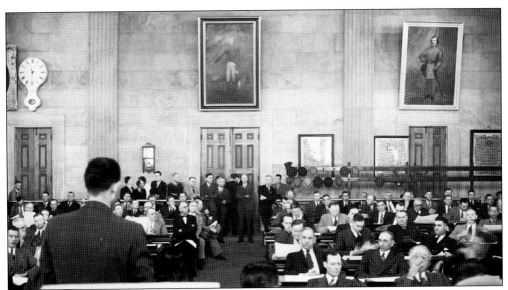

This view shows the vantage point from the House Speaker's rostrum. Here, Gov. Prentice Cooper addresses county registrars in 1940. On the far-left back wall is an original Howard & Davis eight-day wall clock ordered in 1855 for both the House and Senate. In the middle is a copy of Ralph E.W. Earl's 1817 portrait of Andrew Jackson, and on the right is former Confederate general Benjamin Franklin Cheatham. (Courtesy of the Tennessee State Library and Archives.)

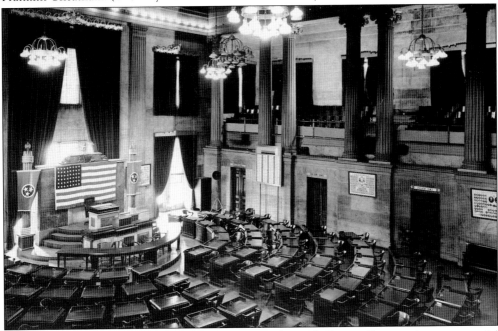

In 1954, a series of photographs was submitted to the Walt Disney Corporation as potential movie sets for Disney's *Davy Crockett: King of the Wild Frontier*. This photograph depicts the House Chamber as a filming site. Notice the lighting strung along the upper perimeter of the ceiling and the decorative chandeliers. Also note the original gilt curtain cornices. This photograph would be instrumental in replicating these curtains during later restorations. (Courtesy of the Tennessee State Library and Archives.)

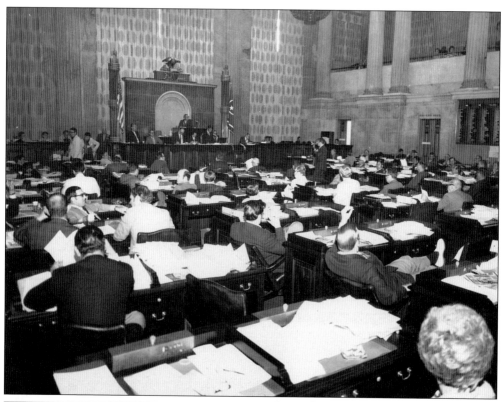

The House Chamber is in full floor session in this 1971 photograph. During the 1969 renovation, new fabric draperies that incorporated the state seal were installed along with new mahogany desks. (Courtesy of the Tennessee State Library and Archives.)

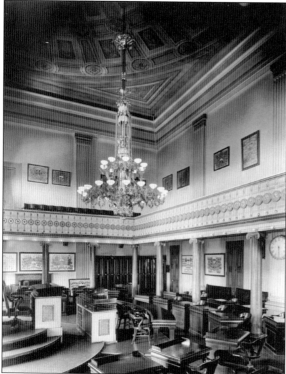

The original Senate gasolier features prominently in this photograph from 1940. The original red-and-white East Tennessee marble desks on the rostrum were ordered in the 1850s and replaced by a larger mahogany rostrum in 1969. The original 1855 Howard & Davis marble eight-day clock can still be seen on the back wall. (Courtesy of the Tennessee State Library and Archives.)

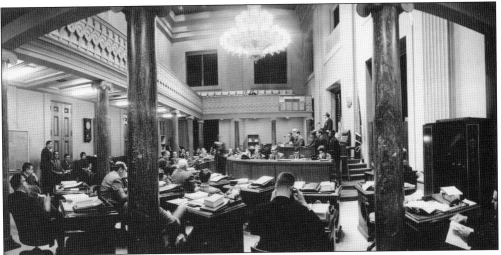

Lt. Gov. Frank Gorrell presides over a Senate floor session in this 1973 photograph. New desks and the large semicircular rostrum were installed in 1969. (Courtesy of the Tennessee State Library and Archives.)

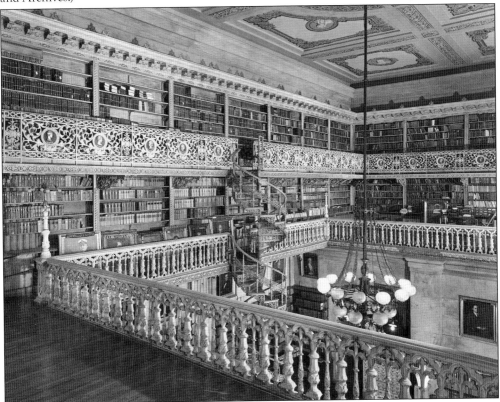

The second and third levels of the library prominently feature the beautiful cast-iron work of Wood and Perot. The third-floor balustrade features 23 bronze portrait medallions of well-known statesmen, literary figures, or famous Tennesseans. Prominent figures include William Shakespeare, Lord Byron, George Washington, Thomas Jefferson, and Andrew Jackson. (Courtesy of the Tennessee State Library and Archives.)

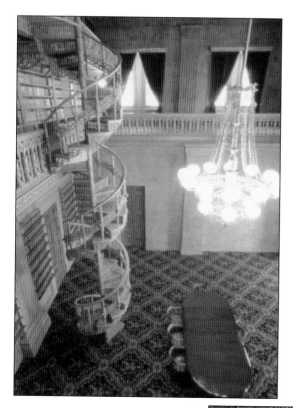

The two most distinctive features in the library are the spiral staircase and the large gasolier. This photograph depicts the handiwork of both Philadelphia manufacturers Wood and Perot, who installed the ironwork and staircase in 1859, and Cornelius & Baker, from whom the gasolier was ordered in 1855. (Courtesy of the Tennessee State Library and Archives.)

German immigrants Theodolphus Knoch and Johann Schleicher painted frescoed ceilings throughout the capitol. Represented on the library ceiling are historian William Hickling Prescott; Judge James Kent; poet Henry Wadsworth Longfellow; Matthew Fontaine Maury, father of modern oceanography; Dr. Gerard Troost, first state geologist; Dr. James Priestly, president of Cumberland University; Dr. Philip Lindsley, minister and university president; and Rev. Charles Coffin, president of East Tennessee College (later the University of Tennessee). (Courtesy of the Tennessee State Library and Archives.)

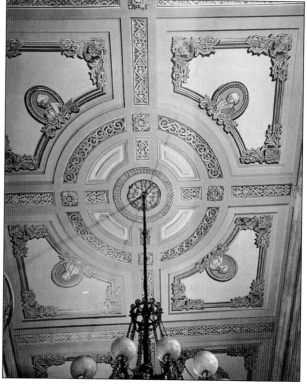

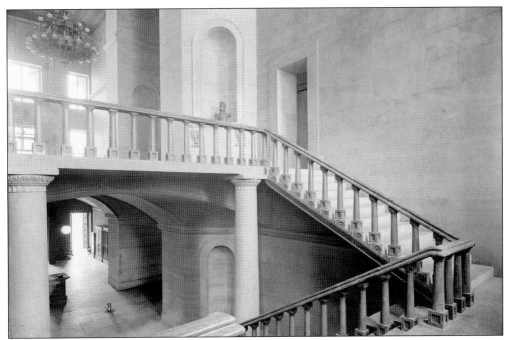

This photograph, taken in 1940, depicts a quiet view of both the first and second floors from the landing of the grand staircase. On the first floor, a spittoon sits on the original limestone floor, while a small globe light fixture dimly illuminates the foyer. On the second floor, visitors were greeted by a bust of Andrew Jackson and the imposing gasolier, now outfitted with electric light fixtures. (Courtesy of the Library of Congress.)

In 1938, during Gov. Gordon Browning's administration, significant updates were made to the Governor's Office and Supreme Court Chamber. This photograph shows a conference room. This room as well as the reception room were added. Walls were removed to provide two long and spacious areas, one public and one private. A local architectural firm designed the room in the Georgian Revival style. (Courtesy of the Nashville Public Library, Metro Nashville Archives.)

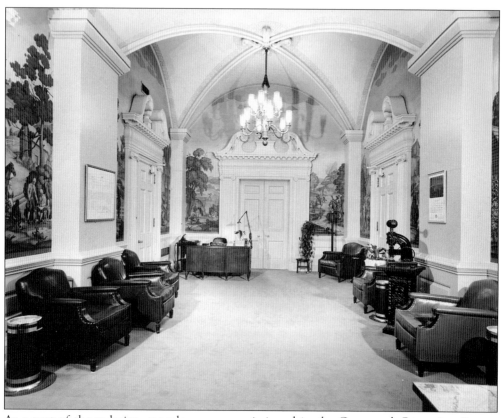

As a part of the redesign, murals were commissioned in the Governor's Reception Room. Internationally recognized muralist George Davidson was chosen for the job. He designed 11 allegorical murals to cover the room and depict major events in Tennessee history. To the right in this picture can be seen a state seal embosser used since the late 19th century. (Courtesy of the Tennessee State Library and Archives.)

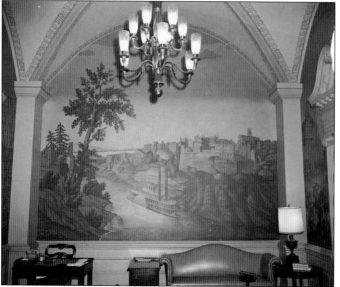

While Davidson designed the murals, another artist, Jirayr Zorthian, painted the scenes. Zorthian was an Armenian immigrant and graduate of Yale University School of Fine Arts. The murals include Nashville during the 1850s, a Native American village, De Soto along the Chickasaw Bluffs, a meeting of the Watauga settlers, the Battle of the Bluffs, the signing of the Cumberland Compact, and Andrew Jackson at the Hermitage, among others. (Courtesy of the Tennessee State Library and Archives.)

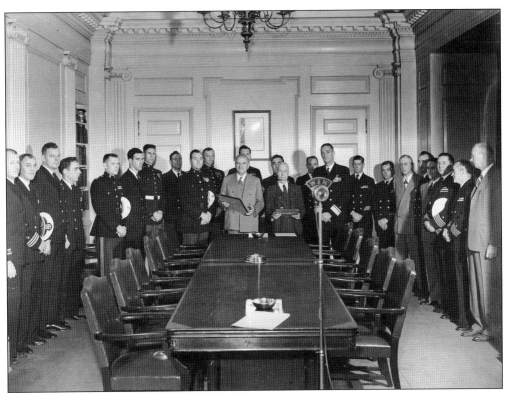

Representatives from the Navy and Marines gather with Gov. Jim McCord in the governor's private conference room for this photograph, taken in the late 1940s. In the background can be seen the Georgian Revival woodwork installed throughout the governor's suite. Also, notice a microphone from the famed WSM radio station in the foreground. (Courtesy of the Tennessee State Library and Archives.)

In 1957, the 80th Tennessee General Assembly appropriated funds for extensive interior renovations. Here, the east entrance lobby has been redesigned into a welcoming waiting area complete with seating, display cases, and a reception desk. While difficult to see in this photograph, the original frescoes have also been repainted under the direction of noted fresco artist Allyn Cox. Also, the original limestone floors have been replaced with Carthage marble. (Courtesy of the Tennessee State Library and Archives.)

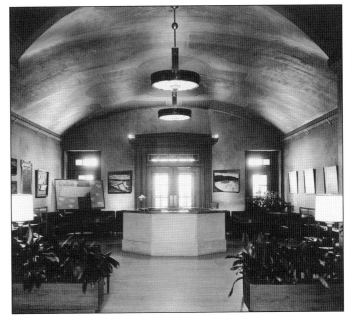

During the 1980s, the interior was carefully restored to as close to how it looked during the 19th century as possible. Here is the first-floor hallway facing north. Notice the retouched frescoes, gilded ceiling medallion, and replica gasoliers. (Courtesy of Nashville Public Library, Metro Nashville Archives.)

This photograph shows the second-floor legislative hall just before session in 1994. The Speaker's rostrum in the House Chamber is framed perfectly through the doorway. The two gasoliers are original from 1857 and remain there even today. (Courtesy of Nashville Public Library, Special Collections.)

Four

THE CAPITOL GROUNDS

After the Civil War, attention turned to developing the capitol grounds. In 1870, the legislature passed "An Act to Improve the Capitol Grounds" and allocated $20,000 for labor. John Bogart, a New York engineer who had worked with Frederick Law Olmsted on New York's Central Park, was hired to design the grounds. Just prior to the war, plans were drawn up for the grounds, but they were lost during the chaotic war years. It is believed that Bogart worked with former commissioners to develop a new plan that closely resembled the original.

 Since the war, the capitol grounds have evolved from a treeless construction site to a beautiful park where Tennesseans have memorialized significant people and events in the state's history. Over the years, the grounds have been made and remade as new generations decide how they pay tribute to the past. From tent encampments of Federal soldiers to parklike pathways and statues, each generation places its mark on Capitol Hill. This chapter will document the evolution of the landscape, from the design of the East Garden to the installation of popular statues like the Andrew Jackson equestrian and the Tennessee World War I hero Alvin C. York. It will document how the grounds became the final resting place of Pres. James K. Polk and First Lady Sarah Childress Polk (the only state capitol to bear that honor). From the north, south, east, and west, the lands that surround the capitol have provided a canvas of sorts so that the Tennessee State Capitol might be properly set with distinction on the landscape. The story of the capitol grounds is not just a story of physical change but rather an examination of how and who Tennesseans choose to honor—an exercise that is always evolving.

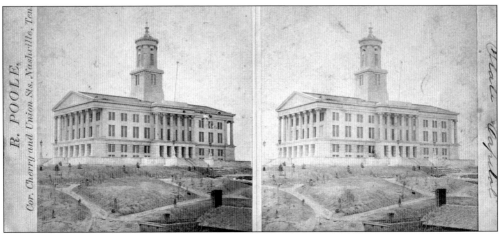

This early-1870s view depicts the excavation of walking paths, the east steps, and the terrace where the Clark Mills equestrian statue of Andrew Jackson now sits. Also, as suggested by Samuel Morgan, small cedar trees have been planted along the walkways. It was believed that cedars would grow best given that the original site was covered in them. Today's pathways in the East Garden still maintain a similar layout. (Author's collection.)

Here, the photographer captured the southwest view of the capitol some time around the late 1860s or early 1870s. Water runoff was a constant problem on the barren hilltop. Notice the pile of dirt on the left. Laborers deposited over 35,000 cartloads of soil in order to transform the rugged limestone outcroppings into a lush landscape suitable for trees and shrubs. (Courtesy of the Tennessee State Museum.)

The development of the capitol grounds took place from 1871 to 1877. In this photograph from the mid- to late 1870s, the walkways are nearly completed with the retaining wall along Cedar Street (today Dr. MLK Jr. Boulevard). (Courtesy of the Tennessee State Museum.)

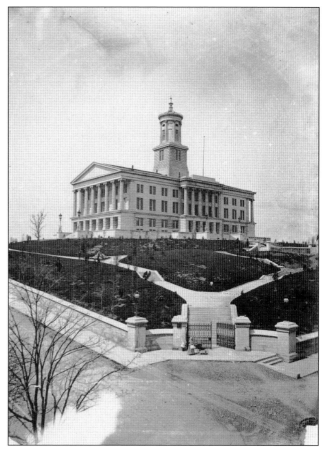

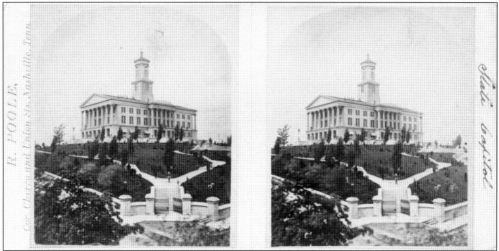

The southeast gate figures prominently in this photograph. The prewar plans for the grounds designed by William Prichard called for the southeast gate entrance to be the primary public access point to the capitol. During the 1870s, Bogart retained this design, as seen here. Indeed, this vantage point would be photographers' most favored view of the building for most of the 19th century. (Courtesy of the Tennessee State Museum.)

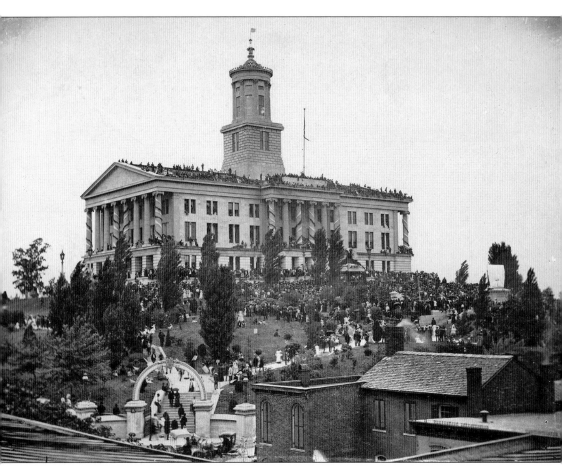

This iconic photograph captures one of the most remarkable days at the capitol, the unveiling of Clark Mills's equestrian statue of Andrew Jackson on May 20, 1880. The day marked Nashville's centennial celebration. The statue remains covered in this image with the crowds along the roof and the edge of the second floor. The capitol columns have been decorated with bunting. (Courtesy of the Tennessee State Library and Archives.)

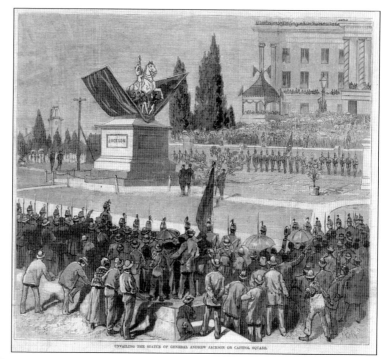

Frank Leslie's Illustrated Newspaper published this illustration of the unveiling of the equestrian statue of Andrew Jackson. At the precise moment of the unveiling, a group of militia soldiers hidden inside the clamshell-like covering pushed open the double-sided curtain. (Courtesy of James A. Hoobler.)

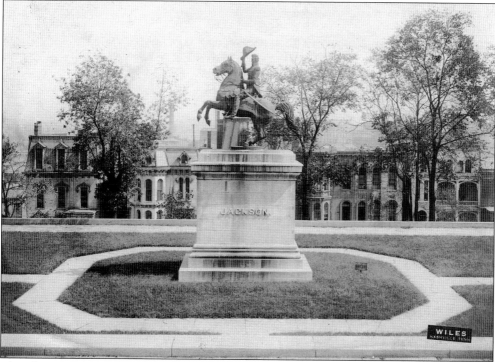

This photograph was taken by Wiles Studios and shows the Clark Mills equestrian statue around 1900. The Victorian mansions along Park Place form a stately backdrop. By the 1950s, the last of these elegant homes had been demolished to make way for the new Cordell Hull Building. (Courtesy of the Tennessee State Library and Archives.)

53

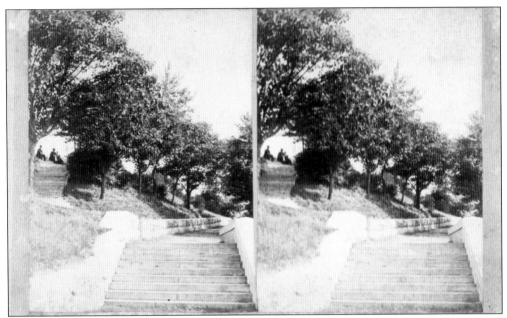

According to a historic structures report, landscape architect John Bogart developed a plan that was "chiefly notable for the treatment of the steep site and the series of graded sidewalks and stairs provided for ascending the hill to the capitol." This photograph, taken in the 1880s, reveals the parklike paths and stairs. (Courtesy of the Tennessee State Museum.)

This photograph was taken after 1891 and shows the walking paths of the grounds. It is unclear what the triangular island in the walkway is in the foreground. (Courtesy of the Tennessee State Library and Archives.)

On September 19, 1893, a grand funeral procession left Polk Place, the former home of Pres. James K. Polk and First Lady Sarah Childress Polk, and ended on the northeastern slope of the capitol grounds. After the death of Sarah, family members contested the will of the former president, and the property was sold to real estate developers. The State of Tennessee offered the grounds of the capitol for the relocation of the tomb. (Courtesy of the Tennessee State Museum.)

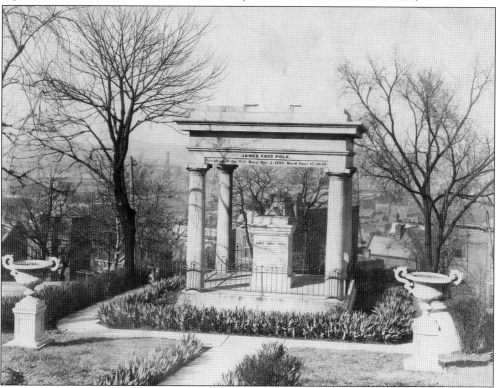

President Polk died on June 15, 1849, and was buried in the Nashville City Cemetery for the first year. During that time, William Strickland designed his tomb. Since Polk had requested to be buried simply, Strickland's design reflects those wishes. The four Doric columns are unfluted and support a plain yet dignified entablature. The two cast-iron urns were brought from Polk Place and remain next to the tomb to this day. (Courtesy of the Tennessee State Library and Archives.)

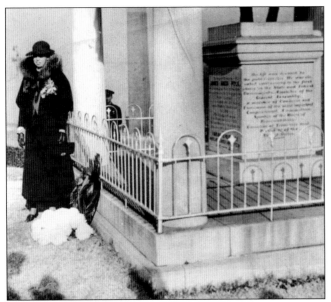

In 1934, Pres. Franklin D. Roosevelt and First Lady Eleanor Roosevelt visited Nashville on their way to Warm Springs, Georgia. The president took the opportunity to inspect several Tennessee Valley Authority sites, including construction of the Norris Dam. While in Nashville, he visited the Hermitage and Fisk University. The First Lady, escorted by local Boy Scouts, placed a wreath on the tomb of Pres. James K. Polk and First Lady Sarah Childress Polk. (Courtesy of the James K. Polk Memorial Association, Columbia, Tennessee.)

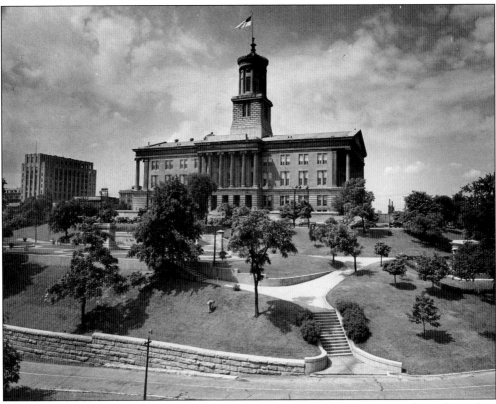

This striking image, taken in 1941, shows the East Garden and its grounds. The Polk tomb is partially shrouded by trees on the right, and the Jackson equestrian statue is to the left. As stated in the historic structures report, the capitol grounds were developed to be a pleasure grounds for the public with many curving walkways, fountains, and ponds. (Courtesy of the Tennessee State Library and Archives.)

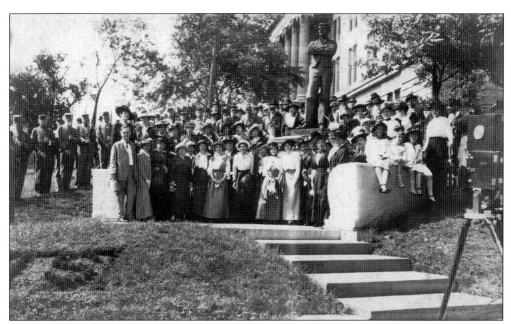

The Sam Davis monument was unveiled on April 29, 1909. Davis was a Confederate scout arrested and convicted of spying by the Union army. He was hanged in Pulaski, Tennessee, on November 27, 1863. After a nine-year fundraising effort led by the *Confederate Veteran* magazine, famous sculptor George Julian Zolnay created a statue of Davis. The monument dedication featured a speech by Gov. Malcolm Patterson and military band music. (Courtesy of the Tennessee State Library and Archives.)

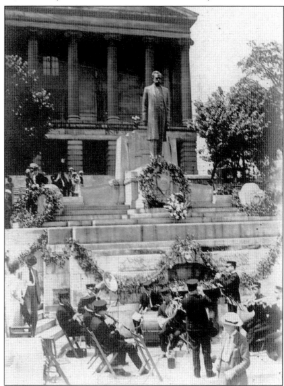

On June 6, 1925, the Edward Ward Carmack statue was unveiled on the south approach to the capitol. Carmack was a former US senator, editor of the *Nashville Tennessean* newspaper, and outspoken prohibitionist. He was killed in a gunfight a block from the capitol on Seventh Avenue. The Woman's Christian Temperance Union led the effort to erect a statue of Carmack, whom they considered a martyr of the Prohibition movement. (Courtesy of the Tennessee State Museum.)

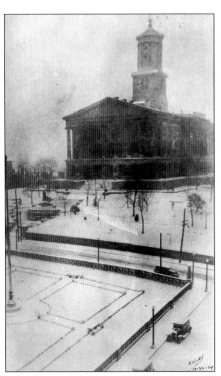

A snowstorm blankets the grounds in this beautiful scene from 1929. (Courtesy of James A. Hoobler.)

In 1951, a record snow and ice storm paralyzed the city as illustrated in this scene of the East Garden. Nashville experienced multiple days of ice and snow. Through it all, the Tennessee General Assembly refused to recess, with both houses maintaining their legislative calendars. One newspaper reported, "The state capitol, scene of much hot debate by legislators, sits serene and unthawed on its hilltop overlooking an ocean of ice and snow." (Courtesy of the Tennessee State Library and Archives.)

In 1927, members of Chapter No. 1 of the Royal and Select Masters of Freemasons buried a time capsule on the southeast capitol grounds and placed this monument on top. The capsule was meant to remain sealed for 100 years and is set to be opened in 2027. (Courtesy of the Tennessee State Library and Archives.)

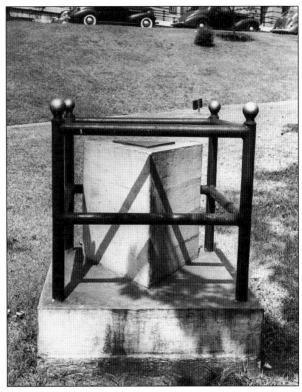

This tablet is barely legible, but it marked the spot of a tree dedicated to David Crockett. During the mid-1890s, the people of Lawrence County planted a black maple from the Crockett homestead. A 1904 article in the *Nashville Tennessean* newspaper reported that the tree was nearly dead. Even after the tree's removal, this marker remained into the 1940s, when this photograph was taken. (Courtesy of the Tennessee State Library and Archives.)

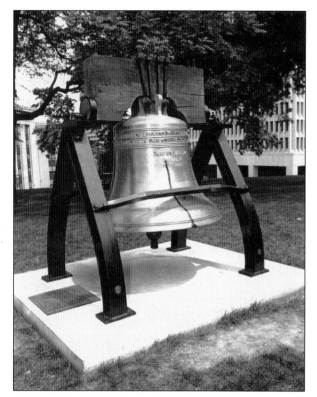

In 1950, to encourage the purchase of savings bonds, the US Treasury Department made 52 exact replicas of the Liberty Bell, with each bell touring its respective US state or territory. Tennessee's bell toured 67 towns throughout the state. (Courtesy of the Tennessee State Museum.)

On December 13, 1968, Gracie York, wife of Tennessee World War I hero and Medal of Honor recipient Alvin C. York, unveiled this two-ton bronze statue of her husband. Standing alongside her is the world-renowned sculptor of the statue, Felix de Weldon. Alvin York passed away in 1964. The following year, the state legislature allocated $35,000 to commission the monument. De Weldon's most well-known work is the Iwo Jima flag-raising sculpture at the US Marine Corps Memorial in Washington, DC. (Courtesy of the Tennessee State Library and Archives.)

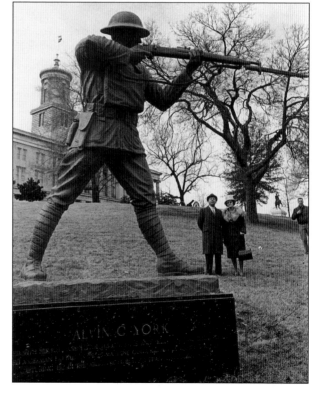

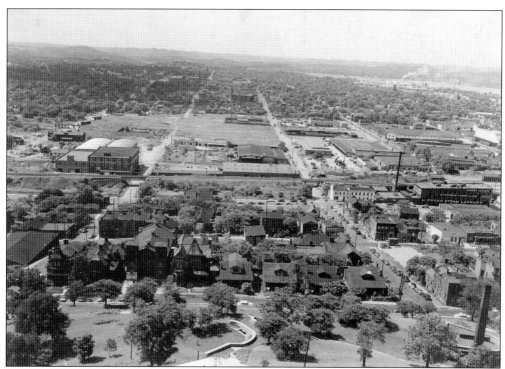

This view was taken from the roof of the capitol facing north around 1949. This was before the mid-1950s Capitol Hill Redevelopment Project, which demolished all of the homes and businesses between the capitol and railroad. Today, this area is James Robertson Parkway, the Bicentennial Capitol Mall State Park, Nashville Farmer's Market, Tennessee State Museum, and Tennessee State Library and Archives. (Courtesy of the Nashville Public Library, Metro Nashville Archives.)

In the fall of 1961 and spring of 1962, capitol landscapers planted 600 varieties of trees throughout the grounds, including magnolias, hackberries, red oak, willow oak, cedars, and dogwoods. Many of these trees are still present to this day. (Courtesy of the Nashville Public Library, Metro Nashville Archives.)

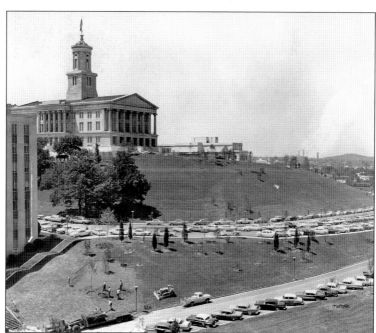

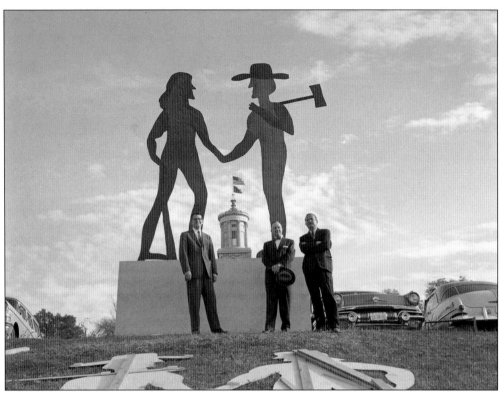

Not all monument proposals become a reality. In 1958, state and city officials collaborated with Puryear Mims on a monument to Nashville founders James Robertson and John Donelson. After state officials quibbled with the design, a revised version was accepted by the city and placed at the site of Fort Nashborough on First Avenue rather than Capitol Hill. Here, local sculptor Puryear Mims stands with Mayor Ben West in front of a model. (Courtesy of the Nashville Public Library, Metro Nashville Archives.)

This photograph, taken in 1961, shows the north slope of Capitol Hill after it had been completely cleared and graded. The service road at the bottom connected James Robertson Parkway with a large parking lot midway up the hill. (Courtesy of the Nashville Public Library, Metro Nashville Archives.)

Workers installed the statue of Pres. Andrew Johnson on the southeast side of the capitol grounds in 1995. The bronze statue was designed by Knoxville artist Jim Gray. Greeneville residents and legislators advocated for the monument for years. It was dedicated by Gov. Don Sundquist on October 18, 1995. (Both, courtesy of James A. Hoobler.)

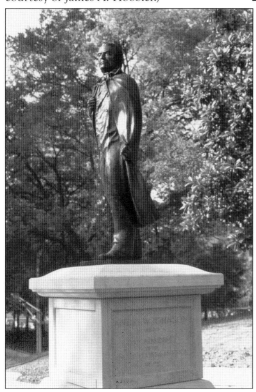

In July 1999, the Tennessee Legislative Black Caucus, along with Gov. Don Sundquist, dedicated a monument to the Middle Passage and planted a scarlet oak on the southwest grounds. It memorialized the Africans that lived through or died during the Middle Passage, the treacherous Atlantic Ocean trade route in which enslaved Africans were transported to the Americas. (Author's collection.)

This memorial was established on the north slope of the capitol in 1995 to honor the stonecutters and masons. It consists of original fragments from the massive columns of the capitol, which were replaced during the 1950s. In 1999, it was named for Charles Warterfield, who had worked on both the 1950s and 1980s restorations. (Photograph by © John Guider; courtesy of the Tennessee State Museum.)

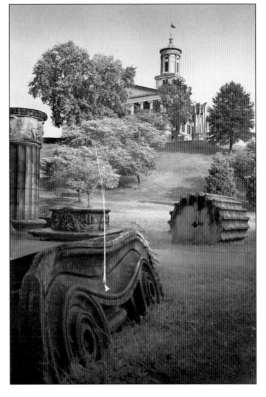

Five

Preservation and Restoration

Wind, water, and time. Three ingredients when put together can tear down mountains and carve the Grand Canyon.

For the Tennessee State Capitol, it took about 100 years for these elements to degrade the stone building to a degree that a multiyear restoration project was necessary. By the 1950s, the building's exterior was showing its age. Cracks became more evident. Gaps between the joints became wider. The grand columns along each portico showed severe deterioration. It was not uncommon for large pieces of the Ionic capitals of the columns to break off and fall to the terrace below. Even on the inside, modern conveniences like air-conditioning, restrooms, and elevators were desperately needed.

For these reasons, the 78th, 79th, and 80th Tennessee General Assemblies authorized and funded a multiyear restoration project from 1956 to 1959 that overhauled the building both on the outside and inside. Under the direction of the Capitol Hill Area Commission (soon to become the State Building Commission) and Gov. Frank Clement, the state sought bids from local contractors. Two noted architectural firms—Victor H. Stromquist and Woolwine, Harwood, and Clark—signed on to oversee the delicate design treatments. A local construction company, Rock City Construction, was named the general contractor over the entire project. During this short but eventful period, about 90,000 cubic feet of limestone was replaced with higher-quality Indiana limestone; the columns and entablature over all four porticoes were replaced; many interior updates, including the library, were made; and finally, in 1959, the Motlow Tunnel was opened to provide easy elevator access from then Charlotte Avenue (today Dr. MLK Jr. Boulevard) to the building's interior. During the late 1980s, the state undertook another preservation project. This time, a state commission oversaw the restoration of many interior spaces, returning them to their original beauty and design, particularly the second-floor library and the Old State Supreme Court Chambers. In the 1990s, the House and Senate Chambers were renovated.

Without the intervention and dedication of state officials and dedicated preservationists during the 20th century, the Tennessee State Capitol would not be what it is today. This chapter will document those efforts and highlight the two main restoration and preservation projects of the late 1950s and 1984–1988.

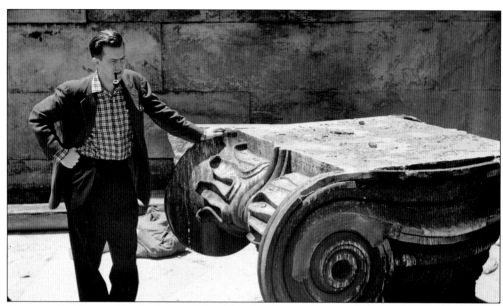

Photographed here is Charles Warterfield. A local architect who specialized in historic architecture and the preservation of historic buildings, Warterfield's lifelong passion was the Tennessee State Capitol. As a young architect, Warterfield photographed the various stages of the 1950s restoration. Many (if not most) of the photographs in this chapter were taken by him. Warterfield also played a major role in the 1980s restoration. (Courtesy of the Nashville Public Library, Special Collections.)

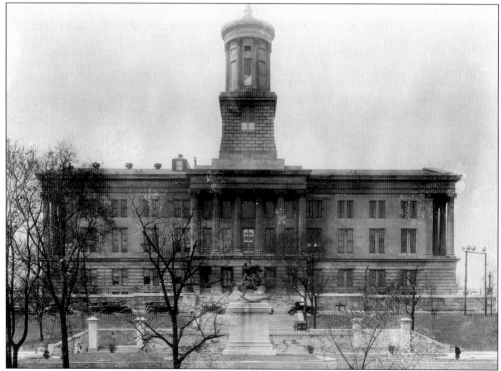

This 1930s photograph shows the building at about 80 years. Notice the darkened columns and entablature along the eastern facade. (Courtesy of the Tennessee State Library and Archives.)

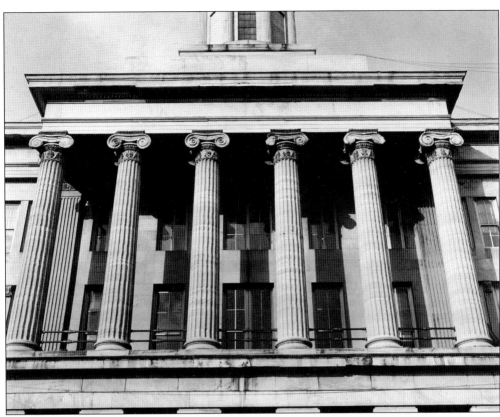

After a survey of the building, it was determined that all 28 columns of the exterior porticos, and the entablature they supported, would need to be replaced. Their removal and reinstallation conducted throughout the years 1956 and 1957 proved to be the most daunting and dramatic phases of the project. (Courtesy of the Tennessee State Library and Archives.)

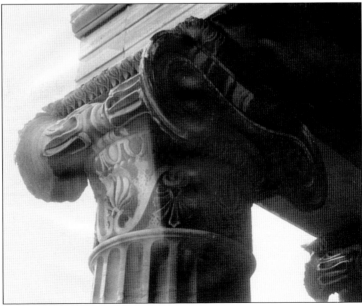

By the 1950s, the deteriorating limestone had become a concern. In 1951, blasting near the capitol caused large chunks of the Ionic capitals to fall to the terrace below. Some state officials suggested removing all the ornamentation, while others considered whether the possibility of an entirely new capitol building might be a better option. (Courtesy of the Tennessee State Library and Archives.)

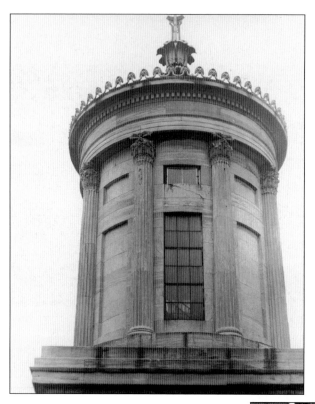

After 100 years exposed to the elements, even the Corinthian tower was showing wear. A complete survey was done prior to construction to identify stones that needed to be fully replaced and those that only needed repair. A closer view of the engaged columns' Corinthian capitals clearly depicts their deterioration. Also, notice the crack in the limestone between the windows of the lantern. (Courtesy of the Tennessee State Library and Archives.)

This unique view was taken from the top of the cupola looking down to the roof below. Notice the weathered columns and pediment. (Courtesy of the Tennessee State Library and Archives.)

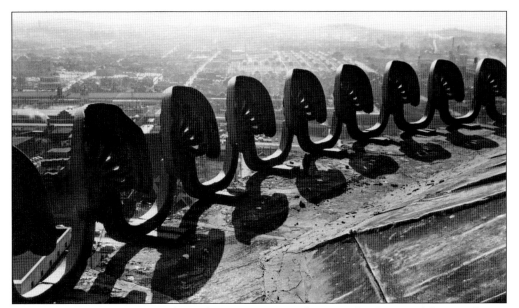

This rare and precarious view shows the iron crowning that encircles the top of the tower's rim. Originally cast by Nashville's T.M. Brennan Foundry in the 1850s, the original ironwork was removed, cleaned, and reinstalled during the project. In the distance, a 1950s view of West Nashville can be seen. Today, this would be considered Midtown. (Courtesy of the Tennessee State Library and Archives.)

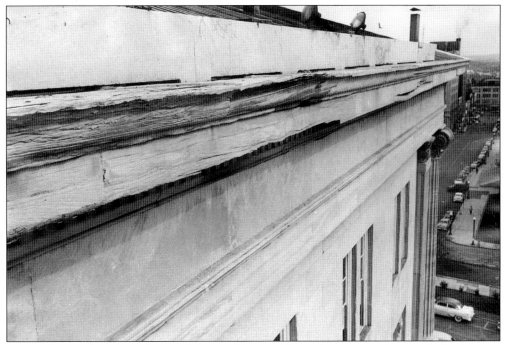

Notice the weathered condition of the entablature. Years of rainwater along with the freezing and thawing process had warped and loosened the native Bigby limestone. Crumbling limestone falling from great heights had long concerned visitors to the capitol. (Courtesy of the Tennessee State Library and Archives.)

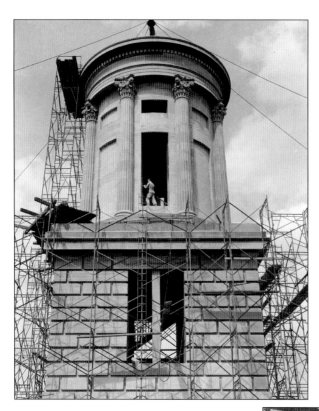

Construction crews began their work in the fall of 1956. The project started with the capitol tower. Scaffolding completely encircled it, and a large steel derrick was installed to lower and lift stone as well as the over 100-year-old cast-iron finial. Notice the construction worker in the open window. (Courtesy of the Tennessee State Library and Archives.)

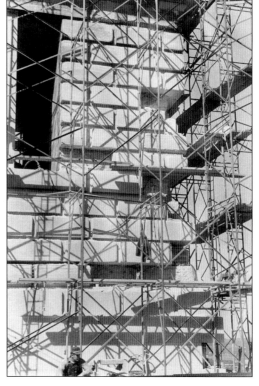

Block by block, deteriorated stones were removed from the building's exterior. This photograph shows the removal of stone from the lower tower. (Courtesy of the Tennessee State Library and Archives.)

Here, the top of the cupola has been completely removed, while scaffolding surrounds the lower tower. The two arms rising above it were part of the 50-ton steel derrick used to remove and replace the stonework. (Courtesy of the Nashville Public Library, Metro Nashville Archives.)

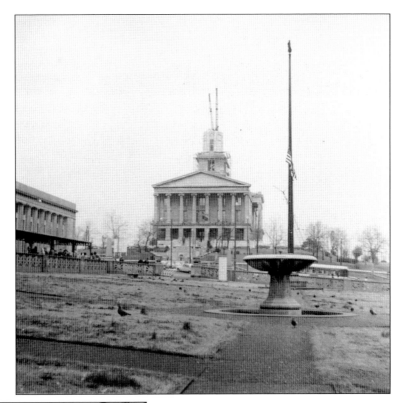

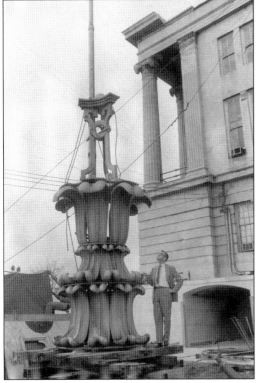

Once the finial was removed, construction crews disassembled it and repainted the tripod on top and all the individual leaves. This photograph offers a glimpse at its impressive scale. (Courtesy of the Tennessee State Library and Archives.)

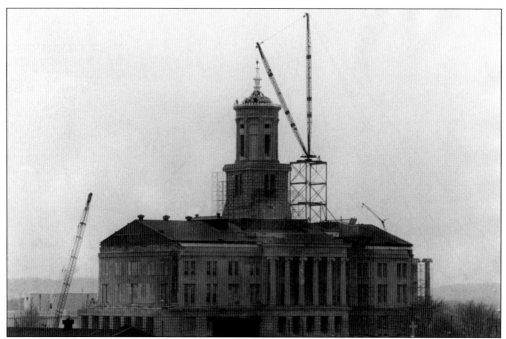

Work is fully engaged all around the building in this striking 1957 photograph. The steel derrick carefully installs the iron finial atop the tower, while the South Portico has been completely removed. To the north, the new columns have been rebuilt and are awaiting the entablature. Crewmen can be seen precipitously overseeing the finial's installation. (Courtesy of the Tennessee State Library and Archives.)

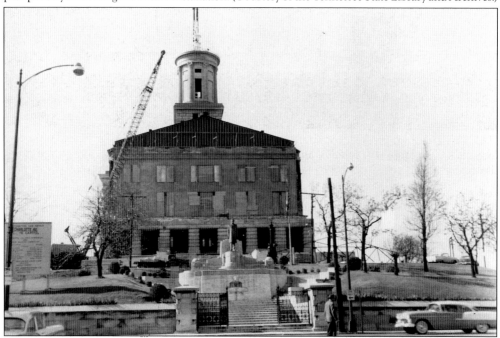

This photograph dates to the early spring of 1957 and shows that the South Portico has been removed. To the lower right, the original iron truss structure of the pediment waits to be reinstalled. (Courtesy of the Nashville Public Library, Metro Nashville Archives.)

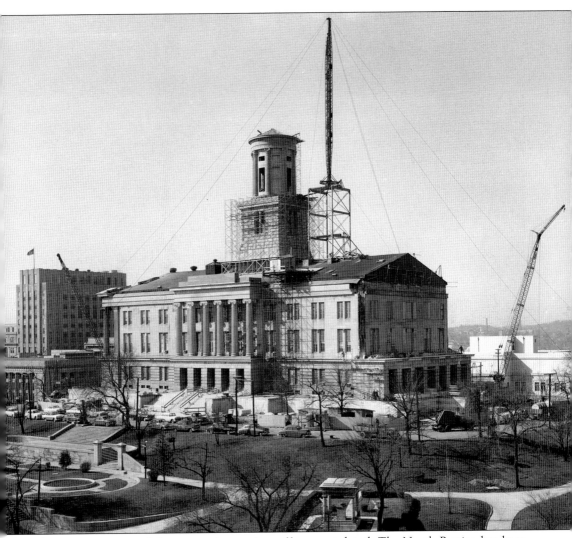

This sweeping view of the restoration project offers great detail. The North Portico has been demolished, including the columns and entablature, while the ironwork along the top of the tower is waiting to be reinstalled. (Courtesy of the Tennessee State Library and Archives.)

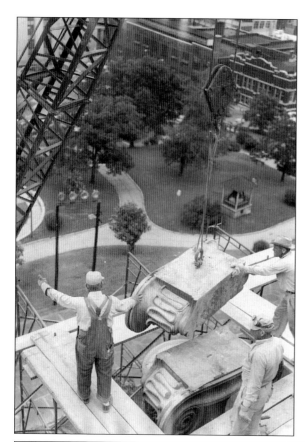

The Winfrey Brothers Company of Knoxville was subcontracted to set the exterior stone. Stones were lifted into place using mobile multiton-capacity cranes. This dangerous and precipitous work was done by skilled technicians without accident or injury to anyone on the job. (Both, courtesy of the Tennessee State Library and Archives.)

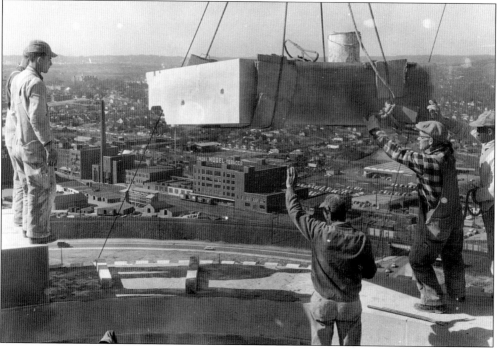

Here, a construction worker guides a new segment of the column's shaft into position at the East Portico. Exact templates were made of the original stones and sent to the Indiana Limestone Company in Bedford, Indiana, where the new stones were quarried and cut. (Courtesy of the Tennessee State Library and Archives.)

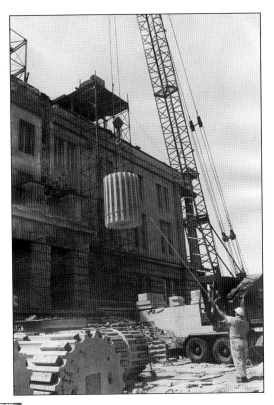

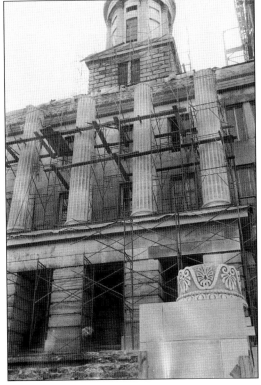

The East and West Porticos were the first to be completed. Here, the East Portico columns are waiting on their capitals to be placed. Notice the finely cut upside-down capital drum in the bottom right. In the case of these capitals, some of the originals were shipped to Indiana so that exact reproductions could be made. (Courtesy of the Tennessee State Library and Archives.)

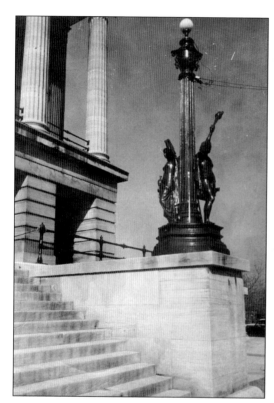

While the life-sized Wood and Perot iron sculptures known as *Morning*, *Noon*, and *Night* had adorned the capitol esplanade since 1859, some people at the time did not like them. In fact, one legislator proposed a bill to remove them, stating that they were "in bad taste, and ludicrously obscene, and immoral in tendency." The bill failed by one vote. (Both, courtesy of the Tennessee State Library and Archives.)

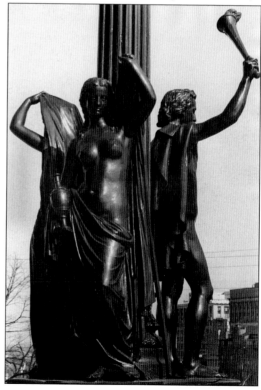

This photograph shows *Morning*. She is in the process of removing the veil of darkness from over her head. (Courtesy of the Nashville Public Library, Special Collections.)

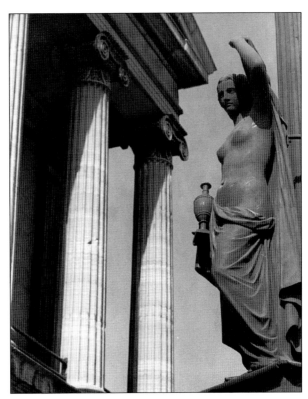

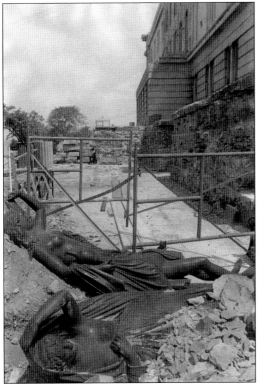

Unfortunately, these beautiful sculptures were a casualty of the 1950s restoration and one of the few original elements not preserved. State architect Clayton B. Dekle told a reporter, "There is no good reason to keep them . . . they're all rusted out. . . . They never really did fit in." Fortunately, one forward-thinking legislator saved one from the rubble. A *Night* statue, like the one seen at the bottom of this photograph, resides to this day on private property. (Courtesy of the Tennessee State Library and Archives.)

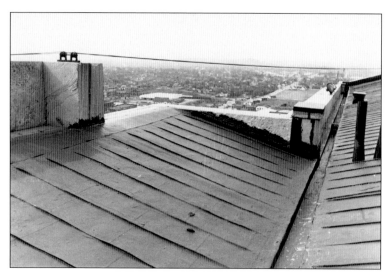

Roof leaks have been a persistent issue throughout the life of the building. In the 1950s, the tin roof installed in the early 1900s was replaced. A new copper roof was installed and took the building back to its original copper roof design. (Courtesy of the Tennessee State Library and Archives.)

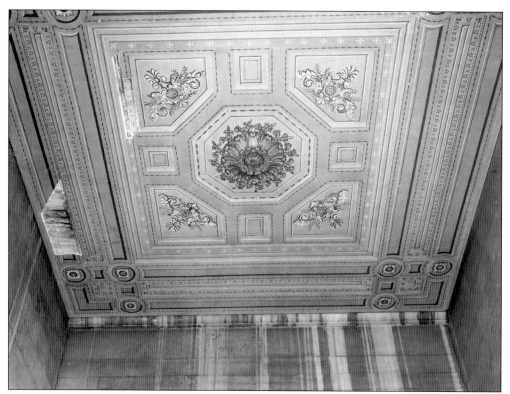

Evidence can be seen of major leaking down the side of the wall as well as damage to the plaster ceilings. During the 1950s interior renovation, all the second-floor plaster ceilings in the House and Senate Chambers, the library, and hallways were replaced. This view is above the second-floor east lobby. The rosettes are believed to have been intended to hold a gasolier that was never purchased. (Courtesy of the Tennessee State Library and Archives.)

This photograph, taken in June 1957, shows the south entrance from Charlotte Avenue (Dr. MLK Jr. Boulevard) with a school bus from Lauderdale County. The finishing touches are being placed on the upper portions of the pediment. (Courtesy of the Tennessee State Library and Archives.)

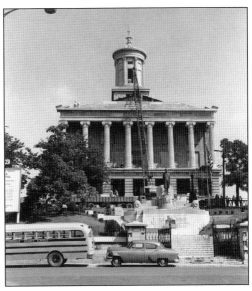

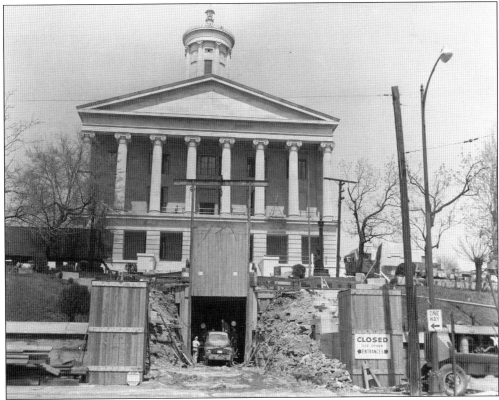

Work began on the Motlow Tunnel in 1958 and was completed in January 1959. This tunnel, which cut 300 feet under Capitol Hill, connected the new elevator bank to the building's three floors. The Tennessee General Assembly named it the Motlow Tunnel after Lem Motlow, nephew to world-famous Tennessee whiskey distiller Jack Daniel. Lem and his son Rep. Reagor Motlow served in the Tennessee General Assembly and had been early advocates for the tunnel. (Courtesy of the Nashville Public Library, Metro Nashville Archives.)

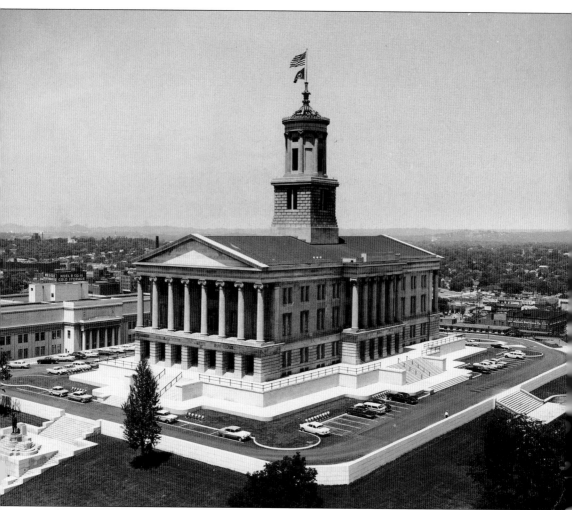

The fully restored capitol building is gleaming in this 1961 photograph depicting the brand-new porticos, upper and lower esplanades, retaining walls, parking lots, and the new Motlow Tunnel at the bottom left corner. (Courtesy of the Tennessee State Library and Archives.)

In 1986, the state appropriated funds for another extensive restoration, this time to focus mostly on the building's interior. The architectural firm of Mendel, Mesick, Cohen, Waite, and Hall were contracted to oversee the project. After meticulous research and a comprehensive historic structures report, much of the interior, including the House, Senate, and Old State Supreme Court Chambers and the library, was restored to its original specifications and beauty. (Both, courtesy of the Tennessee State Museum.)

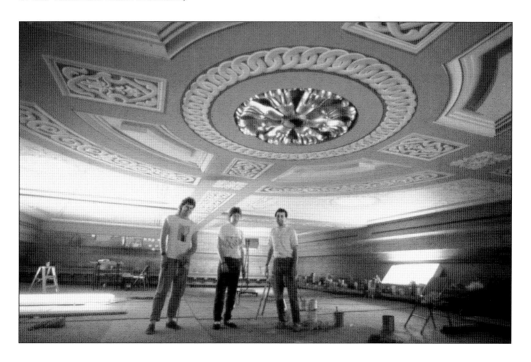

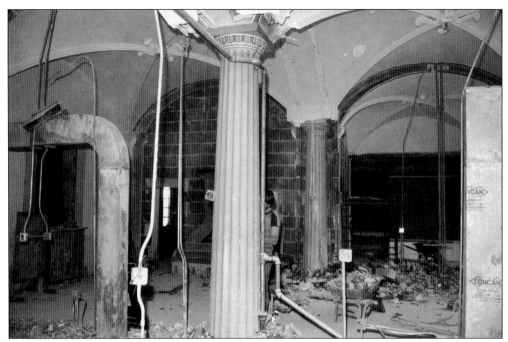

When the Tennessee Supreme Court moved out of the capitol in 1936, the former chamber was subdivided into much needed office space. Offices were added for the secretary of state as well as a new ladies lounge. Here, excavation is underway during the 1980s to uncover the original columns of the room. (Courtesy of the Nashville Public Library, Special Collections.)

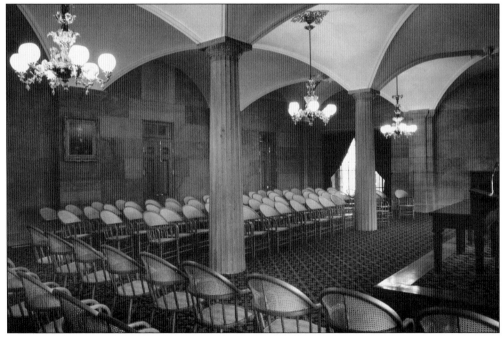

The Old State Supreme Court Chamber was beautifully restored during the 1987 restoration project. The vaulted ceilings and twin fluted columns are highlights of this room. (Courtesy of the Nashville Public Library, Special Collections.)

Six

The Capitol Hill Neighborhood

When George Washington Campbell sold his land to Nashville for the new Tennessee State Capitol, it sat upon the highest hill in downtown. The neighborhood was mostly residential one- or two-story Federal-style wood frame or brick houses. Nearby was Holy Rosary Cathedral, a small brick structure on the northeast side of the hill and the first Catholic church established in Tennessee. The capitol soon transformed the neighborhood. Victorian mansions sprang up around the seat of government, with Campbell's rebuilt house anchoring these palatial residences. After the Civil War, an African American community formed just below Capitol Hill, seen as a safe refuge. African Americans shaped their lives in the shadow of the Tennessee State Capitol and created one of Nashville's first Black neighborhoods.

By 1900, the capitol could no longer contain all the offices necessary for the government to function, and many of the surrounding mansions showed signs of disrepair as Nashville's elite moved to Edgefield or to West End. As a result, the state rented many of these houses to serve as state offices. In 1925, the War Memorial Building began an era of constructing large state office buildings adjacent to the capitol. During the 1930s, two state office structures, the Tennessee State Supreme Court Building and the John Sevier State Office Building, were constructed along the southwest and southeast corners. After World War II, the Cordell Hull Building and a new Tennessee State Library and Archives Building were completed.

Perhaps the most dramatic and controversial change to the neighborhood came during the 1950s, when the Capitol Hill Redevelopment Project reshaped the area to the north and west of Capitol Hill that had been named "Hell's Half Acre" because it was predominately a poor, mostly Black neighborhood. Deeming it as "slum clearance," officials developed a plan to modernize the area and stimulate economic growth. Over the course of a few years, the neighborhood was razed, and a modern parkway was built.

Finally, the 20th century ended with the capitol as the centerpiece of the state's bicentennial gift to the citizens of Tennessee. The Bicentennial Capitol Mall State Park opened in 1996. Today, the capitol rests at the south end of a new neighborhood focused on tourism and Tennessee history that includes the Tennessee State Museum, Tennessee State Library and Archives, the Nashville Farmers Market, and of course, the Tennessee State Capitol itself.

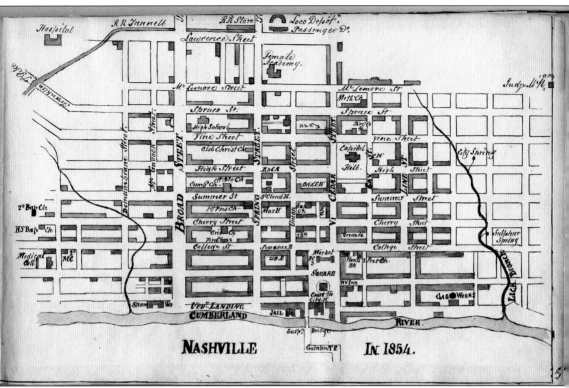

This is an 1854 pen and ink sketch of the streets around Nashville. Capitol Hill is bounded on the south by Cedar Street (today Dr. MLK Jr. Boulevard), the west by Vine Street (today Seventh Avenue), the north by Gay Street, and the east by Park Place (not labeled). Over the years, this neighborhood would be transformed on all sides from private homes and businesses to state government buildings. (Courtesy of the Nashville Public Library, Metro Nashville Archives.)

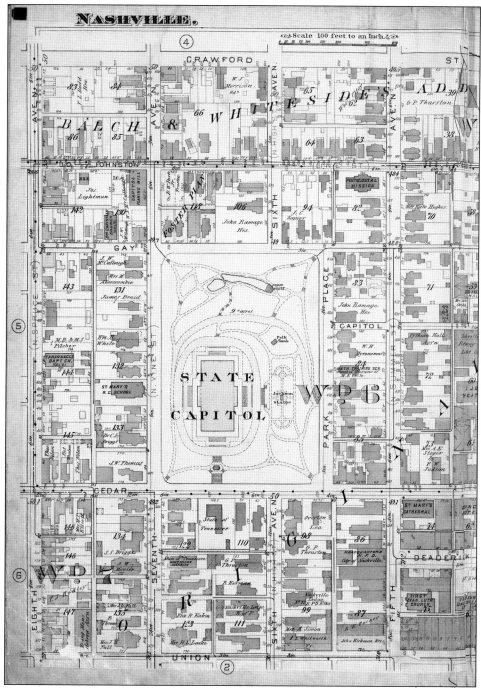

The state capitol and grounds dominate this 1908 map of Nashville. Residential homes, churches, schools, and organizations connect the neighborhood. On the north side, notice how Gay Street and Jo Johnston Avenue travel east to west. This poor working-class neighborhood became the target of the nation's first federally subsidized urban renewal project in the 1950s. Over the next 50 years, the entire Capitol Hill neighborhood was transformed from private ownership to modern state office buildings. (Courtesy of Nashville Public Library, Metro Nashville Archives.)

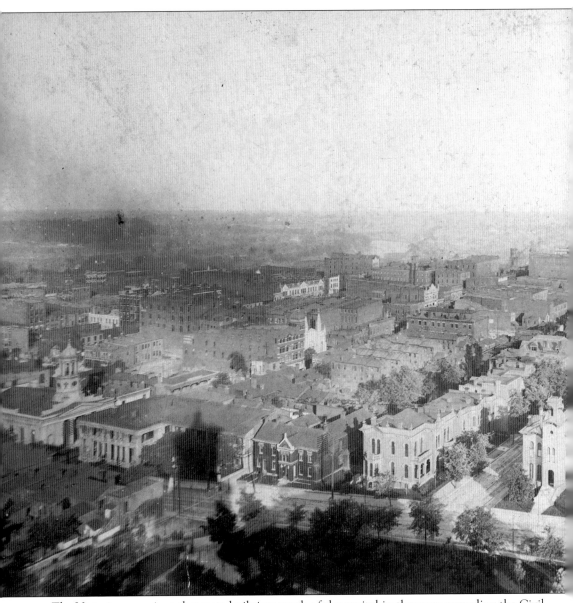

The Victorian mansions that were built just south of the capitol in the years preceding the Civil War are clear in this rare 1890s image. Immediately in front along Charlotte Avenue (today Dr.

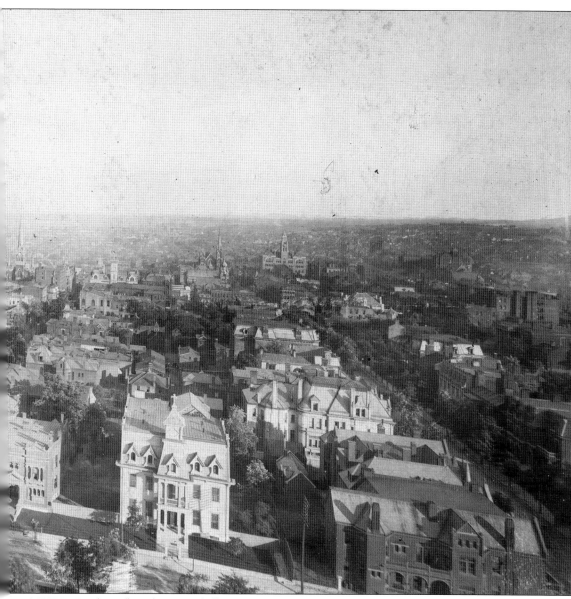

MLK Jr. Boulevard) is the Campbell House, which originally sat upon Capitol Hill. To the far right is Polk Place, where Sarah Childress Polk lived until her death in 1892. (Author's collection.)

Originally built by George Washington Campbell, this house stood on the land the city purchased to build the capitol for $30,000 in 1843, after which Campbell dismantled the house and rebuilt it across the street on the south side of Cedar Street (today Dr. MLK Jr. Boulevard). Andrew Johnson, military governor during the Civil War, and Reconstruction governor William Brownlow both used it as a residence. It also served as the Sisters of Mercy Catholic Hospital, a residence for the Episcopal Diocese of Tennessee, and as an annex for the state capitol before being torn down in 1911 to build Capitol Boulevard. (Courtesy of the Tennessee State Museum.)

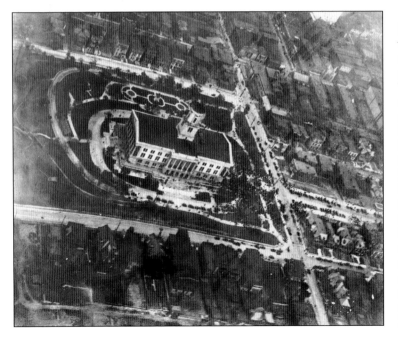

In this early aerial view, the residential neighborhood still surrounds the capitol. This was most likely taken in the 1910s or early 1920s, as the Campbell House has been torn down and Capitol Boulevard has been built. Capitol Boulevard is the broad street that intersects with Charlotte Avenue, which runs vertically and just to the right of the capitol in this picture. (Courtesy of the Tennessee State Library and Archives.)

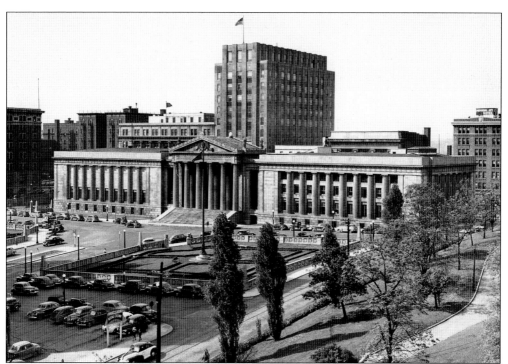

The largest transformation of the capitol neighborhood came on September 1, 1925, when the state opened the War Memorial Building. Designed by local architect Edward E. Doughtery and the New York firm of McKim, Mead & White, it contains a central Court of Honor plaza with the names of the Tennesseans who died during World War I. It served multiple purposes, including a memorial to honor the veterans, expanded state government offices, and a theater for the public. (Courtesy of the Tennessee State Library and Archives.)

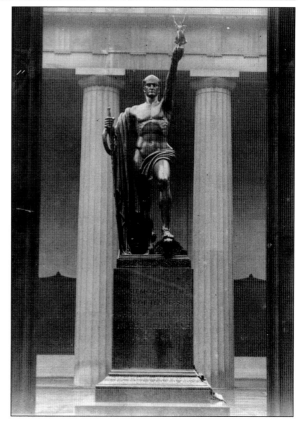

Sculpted by Nashville native Belle Kinney Sholz, this impressive sculpture called *Victory* depicts a male figure standing firmly while holding a peace laurel and sheathed sword in one hand and presenting Nike, the Greek goddess of victory, in the other. Kinney sculpted many other noted works, including the statue of Andrew Jackson in the US Capitol's Statuary Hall. (Courtesy of the Tennessee State Library and Archives.)

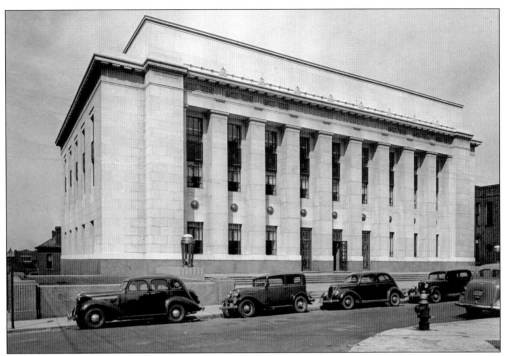

The judicial branch was the first to move out of the capitol building when the Tennessee State Supreme Court Building was dedicated on December 4, 1937. The stripped Classical-style building was designed by Marr and Holman and constructed by Rock City Construction. The project was completed as part of the Public Works Administration. It continues to house the Tennessee Supreme Court, the Court of Appeals, and the Court of Criminal Appeals. (Courtesy of the Tennessee State Library and Archives.)

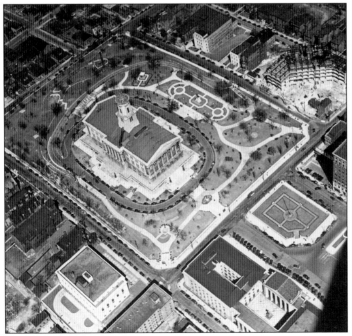

This aerial view captures the Tennessee State Office Building (later renamed the John Sevier Building) under construction. Nashville architect Emmons Woolwine designed the building as a six-story structure with an angled front to the corner of Park Place (today Lamar Alexander Way) and Charlotte Avenue (today Dr. MLK Jr. Boulevard). The building is notable for its stripped Classical design, including bas-relief bronze doors and two murals by renowned illustrator Dean Cornwell. (Courtesy of the Tennessee State Library and Archives.)

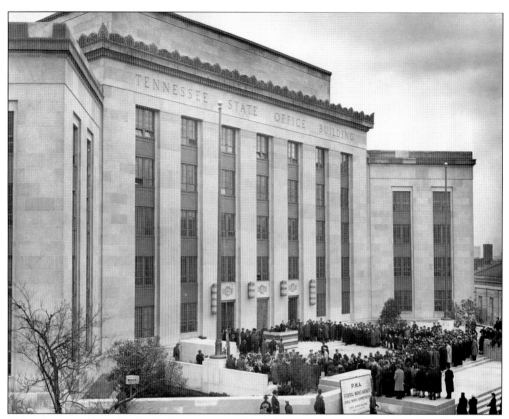

This photograph marks the dedication of the Tennessee State Office Building on March 14, 1940. Notice the sign recognizing the Public Works Administration. Here, Gov. Prentice Cooper makes a speech at the front entrance. When it opened, the state housed several departments in this building, including conservation, agriculture, and insurance, among others. Renamed the John Sevier State Office Building, today it hosts the offices of the state attorney general. (Courtesy of the Tennessee State Library and Archives.)

Even with the addition of the War Memorial Building, Tennessee State Supreme Court, and the Tennessee State Office Building, state government continued to rent or purchase former residences for offices. Here, in 1945, a Victorian mansion along Park Place is used to house the State Planning Commission. (Courtesy of the Tennessee State Library and Archives.)

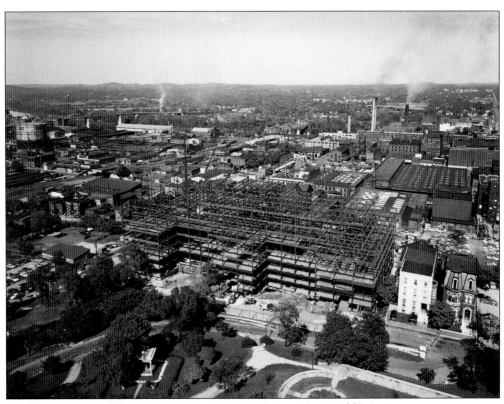

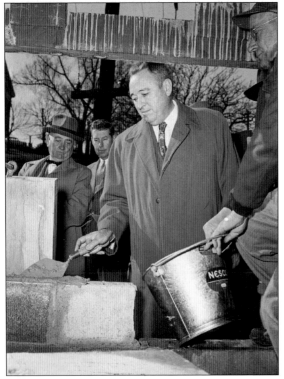

After World War II, state government continued to grow. In 1950, the Tennessee General Assembly appropriated $7.5 million for a new 11-story state office building, which would be named in honor of Tennessee statesman Cordell Hull. This photograph shows the steel frame going up in the fall of 1952. To the right of the steel frame are the final two residential houses that once lined Park Place (today Lamar Alexander Way). (Courtesy of the Tennessee State Library and Archives.)

On December 5, 1952, Gov. Gordon Browning ceremoniously laid the cornerstone to the Cordell Hull Building. With Secretary of State Jim Cummings looking on, Browning uses his trowel to spread the mortar. Before finally placing it, Browning also included a *Blue Book* of 1952, the state's publication of government officials, below the cornerstone. (Courtesy of the Tennessee State Library and Archives.)

In 1951, construction workers excavating the foundation for the Cordell Hull Building uncovered this well-built and sophisticated tunnel under Sixth Avenue. Legend has it that an escape tunnel had been installed during the Civil War. This tunnel might be behind this legend. Experts today speculate it was an intake tunnel for the steam plant constructed during the 1890s that heated the building. (Courtesy of the Tennessee State Library and Archives.)

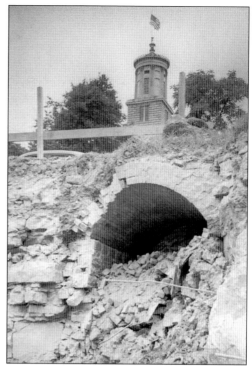

When the Cordell Hull Building was completed in 1954, it housed the Departments of Health and Education and offered year-round air-conditioning, marble floors, and glazed tile. It was redesigned into legislative offices and committee rooms in 2013 and reopened in 2017. This preservation success story led to additional restoration projects in the capitol neighborhood, including the John Sevier State Office Building and the War Memorial Building. (Courtesy of the Tennessee State Library and Archives.)

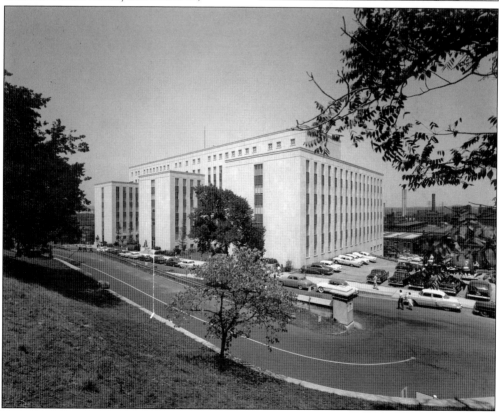

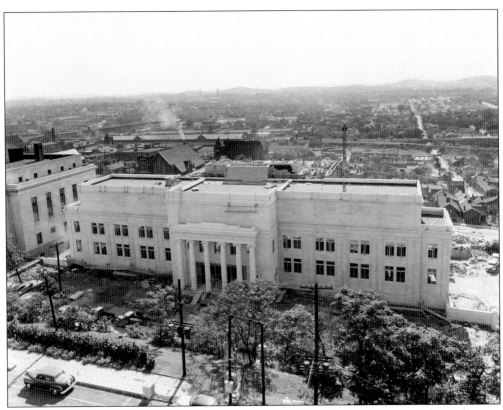

Long before the turn of the 20th century, the state's archival holdings had outgrown their second-story room in the capitol. Over the years, state records were stored in the capitol's attic, basement, and other buildings the state rented. The 1947 Tennessee General Assembly allocated $1.5 million in bonds for the State Library Building's construction, ensuring it would be constructed as state-of-the-art library facilities. (Courtesy of the Tennessee State Library and Archives.)

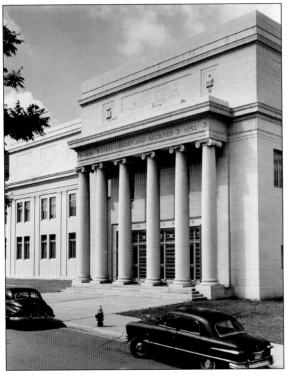

State officials dedicated the new Tennessee State Library and Archives on June 17, 1953. The building was designed by local architect H. Clinton Parrent Jr. in the Neoclassical style and dedicated as a World War II memorial. Its design was meant to complement its neighbors the capitol and Tennessee State Supreme Court Building but not mimic them. (Courtesy of the Tennessee State Library and Archives.)

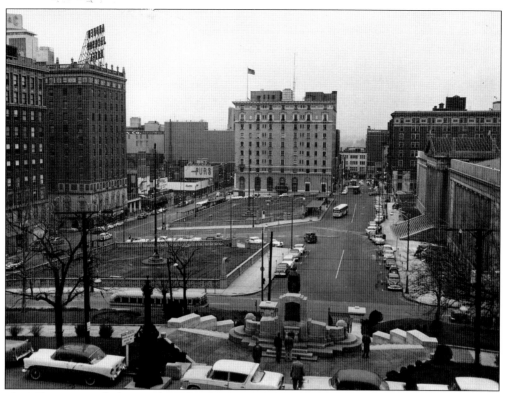

The War Memorial Plaza and south-side neighborhood have been fully transformed from the Victorian houses of the early 20th century. Buildings surrounding the plaza are, from left to right, the Cotton States Insurance Company, the Andrew Jackson Hotel, the Hermitage Hotel in the center, and the YMCA building. Taken from the capitol steps, this view shows why Capitol Boulevard running in front of the War Memorial Building was such a popular parade route. (Courtesy of the Tennessee State Library and Archives.)

Originally organized by the Junior Chamber of Commerce, Clean-Up, Paint-Up, Fix-Up Week took place from April 23 to April 29, 1950. The event's goal was to improve sanitation, cleanliness, and appearance throughout Nashville. Later, this event was run by the City Beautiful Commission. (Courtesy of the Nashville Public Library, Metro Nashville Archives.)

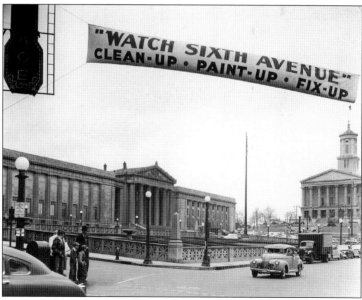

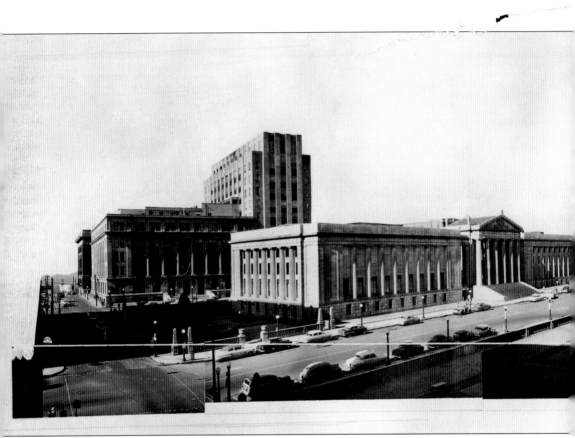

This view shows the capitol and War Memorial Plaza around 1953. On the right are the Cotton States Insurance Company, Andrew Jackson Hotel, and the Elks Club, one of the final Victorian houses left standing. On the left, behind the War Memorial Building stand the buildings of the

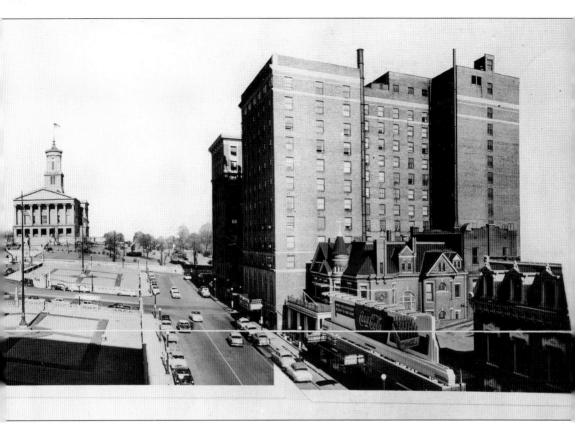

National Life and Accident Insurance Company. The Grand Ole Opry first aired from this location on the insurance company's WSM radio station in 1925. (Courtesy of the Tennessee State Library and Archives.)

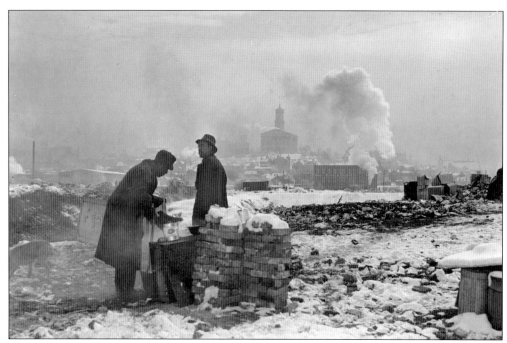

The state capitol looms in the distance in this frigid photograph from 1940 taken near Jefferson Street. Two men warm themselves by a coal stove. Today, this area is near where the Tennessee State Museum is located. (Courtesy of the Nashville Public Library, Special Collections.)

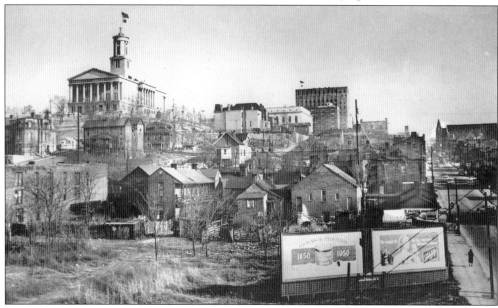

Given the disparaging nickname of Hell's Half Acre, by the 1950s, the low-income neighborhood surrounding the north slope of Capitol Hill housed mostly African American residents. It became a prime area of the Nashville Housing Authority's "slum clearance" and Capitol Hill Development Project. Note on the far right at the top of the hill is the First Baptist Church Capitol Hill, which would become the site of the Nashville sit-in workshops just 10 years later. (Courtesy of the Nashville Public Library, Metro Nashville Archives.)

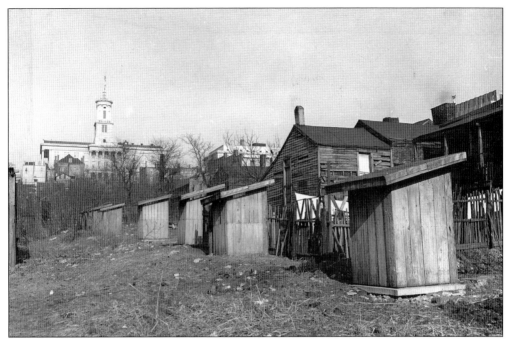
This photograph from 1950 documents the lack of plumbing and modern sanitation systems in this area. It was taken from the west side of Capitol Hill. (Courtesy of the Nashville Public Library, Metro Nashville Archives.)

This photograph provides a unique vantage point of a backyard or alley in the Capitol Hill neighborhood. (Courtesy of the Nashville Public Library, Metro Nashville Archives.)

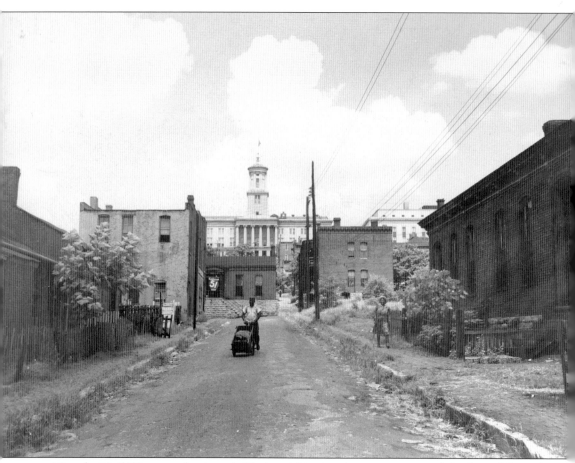

After the Civil War, a predominantly Black neighborhood sprang up around the foot of Capitol Hill to the north and west. This community grew as wealthier families during the early 20th century moved out of downtown and left their Victorian mansions near the capitol. Landlords purchased their houses to split into low-income apartments. By the late 1940s and early 1950s, city and state officials marked this area for redevelopment. (Courtesy of the Nashville Public Library, Metro Nashville Archives.)

First Baptist Church Capitol Hill was a fixture in this community. Begun by famed minister Nelson Merry in the 1840s, it remains one of the city's oldest continuing African American congregations. At this time, it was led by popular minister Rev. Kelly Miller Smith. Beginning in the 1950s, this church became a key gathering place for the growing civil rights movement. In the fall and winter of 1959 and 1960, the Nashville sit-in workshops were held here by Rev. James Lawson, and Dr. Martin Luther King Jr. preached to the congregation many times. Forced out by ongoing urban renewal, the congregation left this building in 1972 to move a few hundred yards away to James Robertson Parkway. This historic building was torn down, and a parking lot remains there today. (Both, courtesy of the Nashville Public Library, Metro Nashville Archives.)

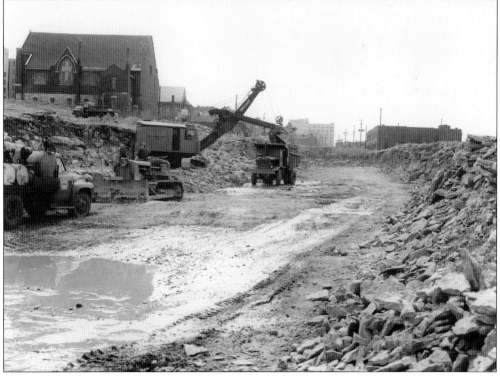

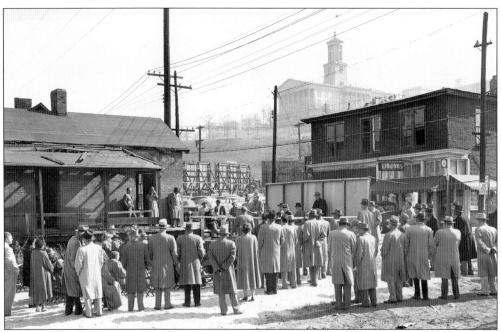

This photograph shows the demolition kickoff ceremonies for the Capitol Hill Redevelopment Project on November 6, 1953. This project was the first urban renewal plan funded by Congress and became a joint effort by city and state officials to remove the neighborhood to the west and north of Capitol Hill and replace it with a parkway, hotels, and apartments. Low-income housing units were built for those displaced from their homes. (Courtesy of the Nashville Public Library, Metro Nashville Archives.)

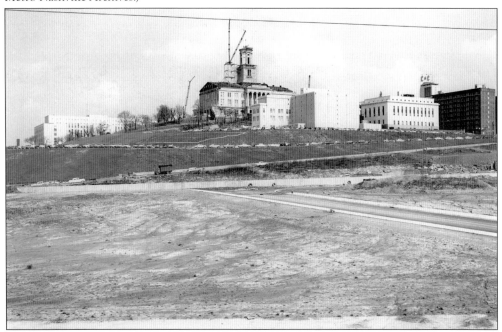

By 1957, the year of this image, all the dwellings and businesses had been completely demolished and the landscape scraped clean. (Courtesy of the Nashville Public Library, Metro Nashville Archives.)

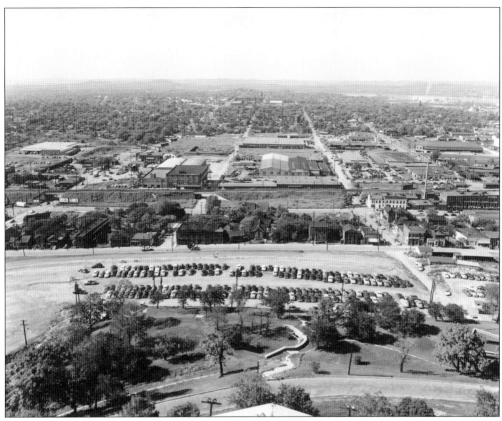

This photograph was taken from the roof of the capitol facing north in September 1952. What remains of the old capitol grounds are in the foreground, and a new parking area that would become Capitol Drive is being constructed. The area to the north of the railroad is today's Bicentennial Capitol Mall State Park. (Courtesy of the Nashville Public Library, Metro Nashville Archives.)

This aerial view was taken in June 1952. Demolition is well underway immediately to the north of the capitol, and Gay Street has been replaced with parking. Notice both the Tennessee State Library and Archives and Cordell Hull buildings are under construction. Demolition of the homes and remaining businesses began in 1953. (Courtesy of the Nashville Public Library, Metro Nashville Archives.)

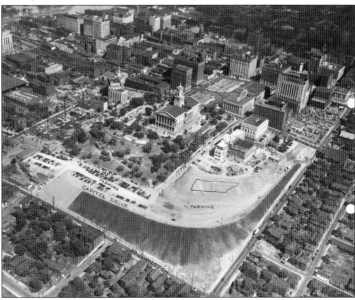

103

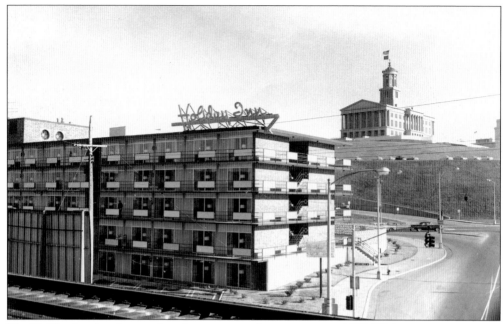

The Holiday Inn hotel opened its doors to capitol-area visitors in 1959. With a construction cost of $1 million, it boasted 158 rooms, a 200-person conference room, and a 40-by-60-foot swimming pool in the front of the hotel. The Andrew Johnson State Office Building sits on the present lot. (Courtesy of the Nashville Public Library, Metro Nashville Archives.)

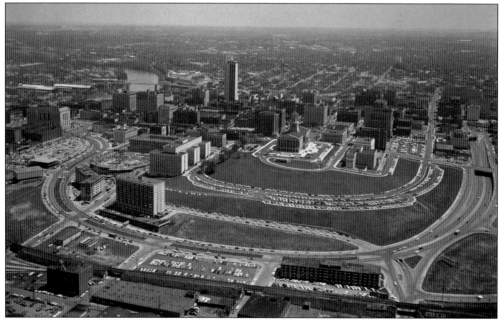

The Capitol Hill neighborhood to the west and north was completely transformed by 1961. The James Robertson Parkway now dominates the area, with the Holiday Inn hotel at the bottom and the new Capitol View apartments rising high above the foot of Capitol Hill. Notice the circular construction site of Municipal Auditorium to the far left. (Courtesy of the Tennessee State Library and Archives.)

By the late 1960s, more room was needed to house offices for the legislative branch. In this 1973 photograph, construction crews have excavated a deep hole in front of the War Memorial Building. Capitol Boulevard was closed, and War Memorial Plaza was transformed into an underground office space and parking deck. Begun in 1971, construction took three years to complete, and the newly named Legislative Plaza opened in 1974. (Courtesy of the Tennessee State Library and Archives.)

The completed plaza featured two fountains that were an homage to the earlier two courtyards along with two flagpoles that mirrored the flagpoles that had been in War Memorial Plaza. Today, war memorials honor veterans from the Korean, Vietnam, and Gulf Wars and fallen highway patrol officers. (Courtesy of the Nashville Public Library, Special Collections.)

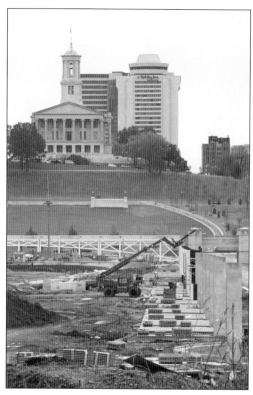

In 1996, the Bicentennial Capitol Mall State Park became the latest major development around Capitol Hill. Designed by Tuck Hinton Architects, the Bicentennial Capitol Mall State Park has become one of the most popular gathering points in Nashville and is home to many festivals, including Nashville's Big Bash New Year's Eve celebration. (Both, courtesy of Nashville Public Library, Special Collections.)

Seven

THE PEOPLE'S HOUSE

The Tennessee State Capitol is more than stone and monuments, politics, and legislation. For generations of Tennesseans, it is the people's house. Not only is it a seat of government, it embodies the people of Tennessee. It has hosted countless school field trips and civic events, celebrations for returning troops and landmark legislation, civil demonstrations and state funerals, and even movie sets. The capitol is a building of the people and for the people of Tennessee. This chapter demonstrates how people have used the capitol and its surroundings as a place to stake a claim to how government works. As the building itself has evolved and endured over the generations, so have the Tennesseans who have used it. As one of the oldest and most historic capitols in use today, the Tennessee State Capitol is more than just the seat of government. It is a symbol of Tennesseans and their resilience, civic engagement, and abiding volunteer spirt.

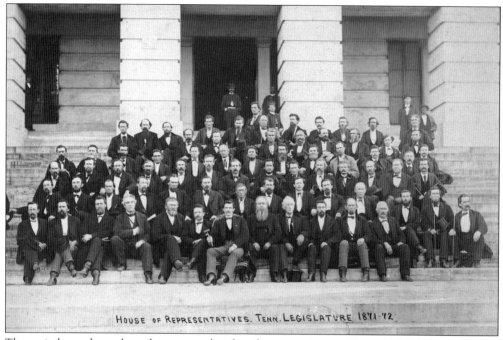

The capitol steps have always been a popular place for group pictures. Here, the 1871–1872 House of Representatives gather to be photographed. (Courtesy of the Tennessee State Library and Archives.)

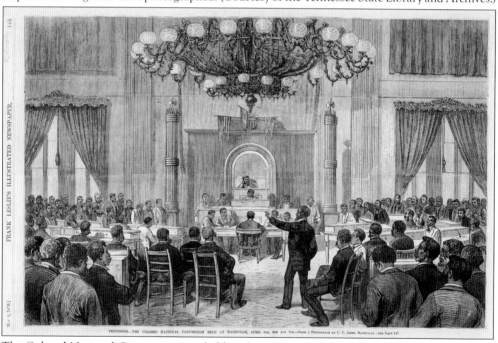

The Colored National Convention was held at the state capitol April 5–7, 1876. This engraving, printed in *Frank Leslie's Illustrated Newspaper* on May 6, 1876, was based on a photograph taken by C.C. Giers of Nashville. The delegates were added to the image. Conventions were held annually in different cities and brought African American leaders together to strategize issues like education, justice, voting, and labor. (Courtesy of the Tennessee State Museum.)

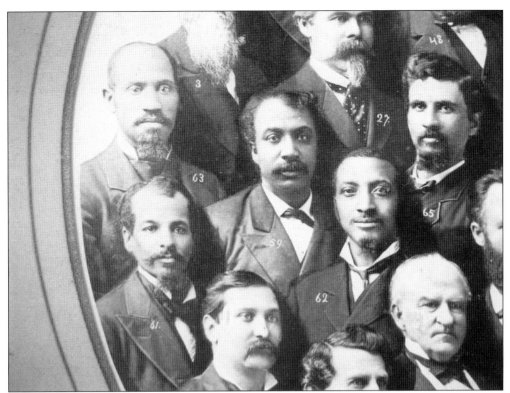

Four African American legislators served in the 42nd Tennessee General Assembly of 1881–1882. Beginning at the top, they are John W. Boyd from Tipton County (63), Thomas Sykes from Davidson County (59), Isaac Norris from Shelby County (62), and Thomas F. Cassels from Shelby County (61). The first African American to serve in the Tennessee General Assembly was Sampson Keeble. Fourteen men served in the 19th century before Jim Crow laws effectively excluded African American leaders from the general assembly until the 1960s. (Both, courtesy of the Tennessee State Museum.)

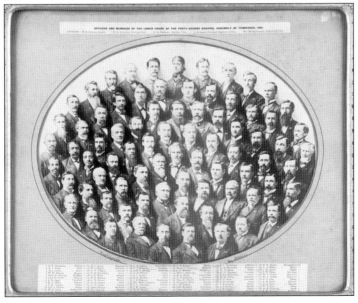

109

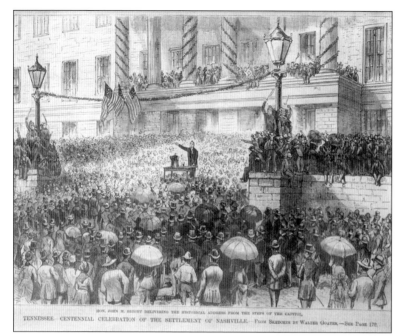

Frank Leslie's Illustrated Newspaper published this rendering of the massive crowd on the capitol's east steps that attended the centennial celebration of the settlement of Nashville. (Courtesy of the Tennessee State Museum.)

Before the War Memorial Building was constructed, the capitol served as a place of reunion and celebration for Tennessee's returning veterans. Here, members of the 1st Tennessee Infantry gather for a photograph just after their triumphant arrival at Union Station in November 1899. The 1st Tennessee fought in the Philippines during the Spanish-American War. It became one of the most decorated units of the war and the last to leave federal service. (Courtesy of the Tennessee State Museum.)

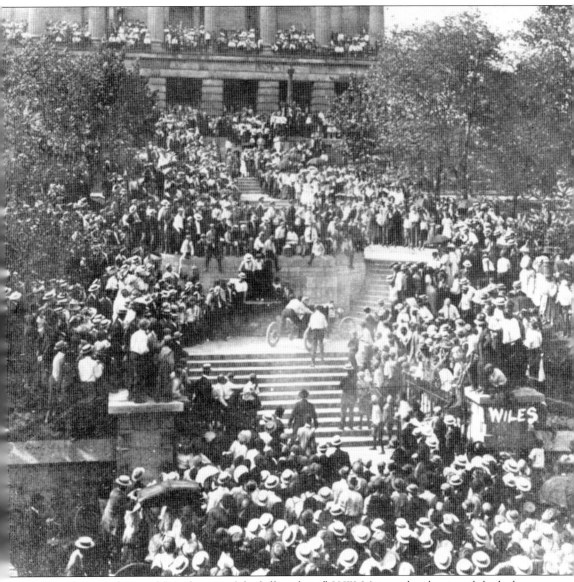

With a banner that read "To the top of the hill, or bust," H.W. Major, a local automobile dealer, climbed all 62 steps of the capitol in his Ford Runabout. He had advertised his publicity stunt in the papers days before. On August 5, 1911, thousands gathered as the automobile roared up each step and then stalled out on the final flight. Finally, he made it to the top and then drove the sputtering and rumbling auto through the halls of the first floor, out the back of the building, and down the steps on the north side. (Courtesy of the Tennessee State Library and Archives.)

A bicycle club enjoys a stop for a photograph on the southwest corner of the capitol. This photograph was taken around 1900, before the Sam Davis statue was erected. (Courtesy of the Tennessee State Library and Archives.)

A group of men poses on the Cedar Street electric streetcar line around 1900. This stop was located on the corner of Cedar Street (today Dr. MLK Jr. Boulevard) and Vine Street (today Seventh Avenue). (Courtesy of the Nashville Public Library, Metro Nashville Archives.)

A crowd has gathered as the funeral carriage of Gov. William B. Bate arrives on March 13, 1905. Since the funeral of William Strickland in 1854, the capitol has often been the place where Tennesseans collectively mourn the loss of important figures. Bate was placed in the first-floor foyer, where the executive branch offices are located. Some have chosen the second-floor rotunda, others the House or Senate Chambers, and some even the library. (Courtesy of the Tennessee State Library and Archives.)

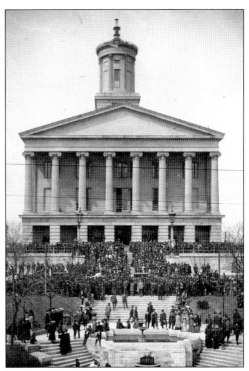

One of the grandest celebrations in Nashville history took place when Tennessee's World War I doughboys returned home in March 1919. Here, members of the 114th and 115th Field Artillery walk through their own Arc De Triomphe along Capitol Boulevard. Thousands gathered along the parade route and at the capitol, where Red Cross nurses were honored with their own section on the steps. (Courtesy of Tennessee State Library and Archives, Collection of the Tennessee Historical Society.)

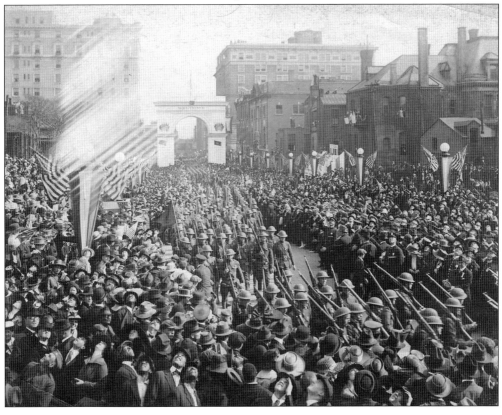

Gov. Thomas Rye signs the Women's Suffrage Bill in the governor's office in 1919 as suffragist leaders look on. One year before the momentous 19th Amendment ratification vote, this resolution represents the first step to establish women's suffrage in Tennessee. (Courtesy of the Tennessee State Museum.)

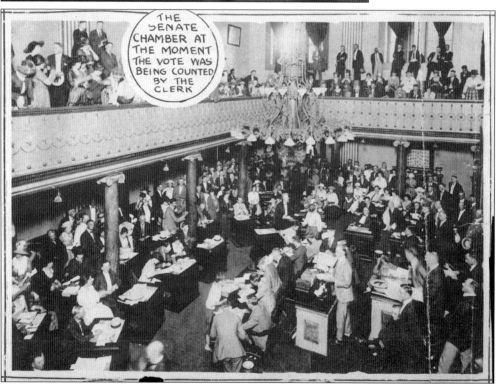

This photograph shows the moment the Senate voted to ratify the 19th Amendment to the US Constitution. This amendment provided voting rights to women. However, many women continued to face legal and cultural barriers to voting and holding office. (Courtesy of the Tennessee State Library and Archives.)

In August 1920, Febb Burn wrote a letter to her legislator son, Harry, and reminded him to "be a good boy" and support the ratification of the 19th Amendment. His vote tipped the balance in the House and guaranteed women's suffrage. Harry Burn (dark suit in background) is pictured here on the capitol steps with other key supporters, including Banks Turner (far left), and Tennessee suffragist Sue Shelton White (far right). (Courtesy of the Library of Congress.)

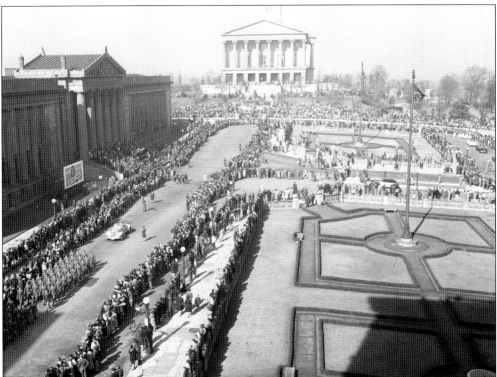

From the 1910s through the 1960s, Capitol Boulevard in front of the capitol and War Memorial Building became a popular parade ground for civic and military parades. Nashville's patriotism is on full display as crowds gather to watch the Armistice Day Parade in this 1941 photograph. This big event was held on March 18, 1941, less than a year before Pearl Harbor. (Courtesy of the Nashville Public Library, Metro Nashville Archives.)

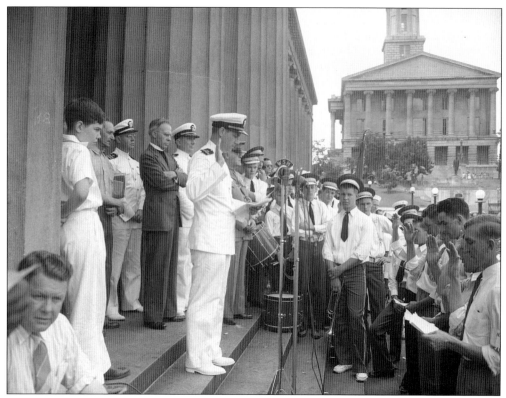

With the capitol in the distance, recruits swear an oath of allegiance and enlist in the Navy on the steps of the War Memorial Building. Six months after Pearl Harbor, June 7, 1942, the nation observed Avenge Pearl Harbor Day and considered it a national day of enlistment. After a parade and ceremonies, 195 "Avengers" enlisted here. The next day, they gathered at Union Station and left for war. (Courtesy of the Nashville Public Library, Metro Nashville Archives.)

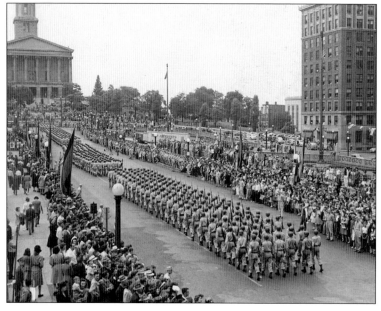

A military parade proudly marches down Capitol Boulevard during World War II. (Courtesy of the Tennessee State Library and Archives.)

Army and Navy officers lead Tennessee's Army Day Parade on April 6, 1949. They are, from left to right, Capt. George E. Fee, US Navy; Col. William Sherwood, Tennessee Military District commanding officer; and Col. Hoyt L. Prindle, Smyrna Air Base commanding officer. They are followed by the Army-Navy-Marine color guard. (Courtesy of the Nashville Public Library, Special Collections.)

A group of Lady Legionnaires marches in front of a band in this 1940s parade. (Courtesy of the Tennessee State Library and Archives.)

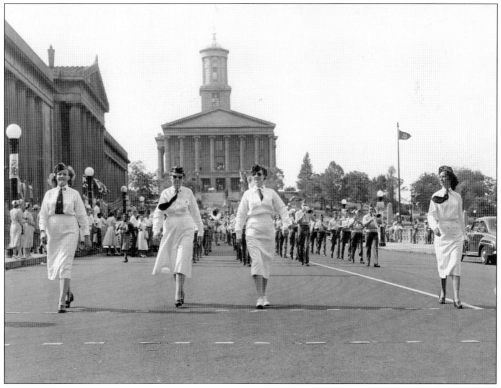

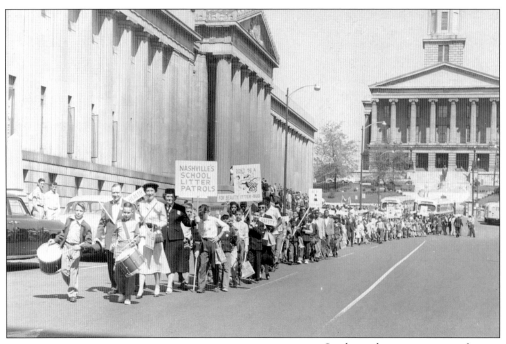

Students drum up support for a cleaner city in the Nashville Schools Litter Parade in 1956. This initiative was a part of the City Beautiful Commission's effort to improve sanitation and cleanliness. This commission eventually transitioned to Metro Parks and then Metro Public Works. (Courtesy of the Nashville Public Library, Metro Nashville Archives.)

Ben Johnson, who was a porter, is possibly one of the longest-serving staff members at the capitol. He worked at the capitol for the better part of 50 years, climbing the tower's 190 steps twice a day to raise and lower the American flag. He became a fixture at the capitol and retired at the age of 79. Porters played important roles like maintenance, cleaning, and giving tours. (Courtesy of the Tennessee State Library and Archives.)

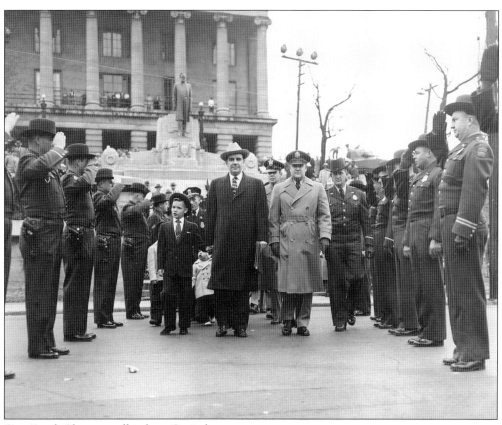

Gov. Frank Clement walks along Capitol Boulevard with his son Robert and family behind him to the War Memorial steps for his inauguration on January 19, 1955. With this term, he became the state's first four-year-term governor. Prior to this, governors served two-year terms. (Courtesy of the Nashville Public Library, Metro Nashville Archives.)

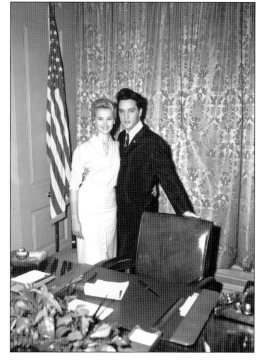

Elvis was in the building. Here, Gov. Buford Ellington's daughter Ann poses with Elvis Presley during Presley's visit to the capitol on March 7, 1961. Presley was there to be recognized by the governor and Tennessee General Assembly for popularizing Memphis and music in Tennessee. Opening his address to a joint session of the Tennessee General Assembly, Governor Ellington introduced the star, proclaiming that in the presence of Presley, he felt like "nothing but a hound-dog." Presley told the audience that this had to be the greatest honor he had ever received. (Courtesy of the Tennessee State Library and Archives.)

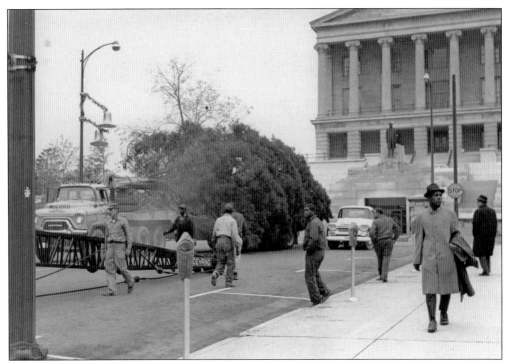

The Christmas tree lighting at the capitol has been an annual tradition since the early 20th century. Here, crews prepare to hoist the tree into place in 1962. The lighting ceremony was held on November 30 with 1,000 elementary students singing carols. (Courtesy of the Nashville Public Library, Metro Nashville Archives.)

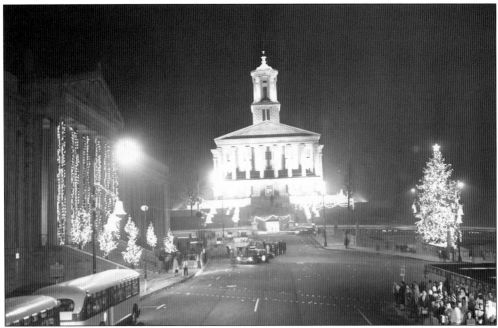

The state Christmas tree illuminates War Memorial Plaza in December 1961. (Courtesy of the Nashville Public Library, Metro Nashville Archives.)

Civil rights demonstrators march east up Charlotte Avenue (today Dr. MLK Jr. Boulevard) toward Capitol Hill during the Freedom March in this 1963 photograph. (Courtesy of the Nashville Public Library, Special Collections.)

This photograph of Archie Walter "A.W." Willis Jr. was used in a 1965 news story profiling his election to the Tennessee General Assembly. Willis became the first African American elected to the Tennessee legislature since the 1880s. He was an attorney for the NAACP in Memphis during the sit-in movement, argued many civil rights cases, and served on Tennessee's first Human Rights Commission and the National Civil Rights Museum Commission. (Courtesy of the Associated Press.)

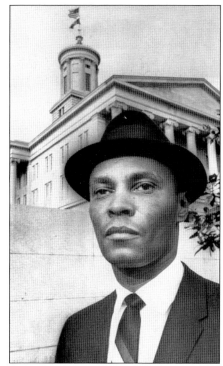

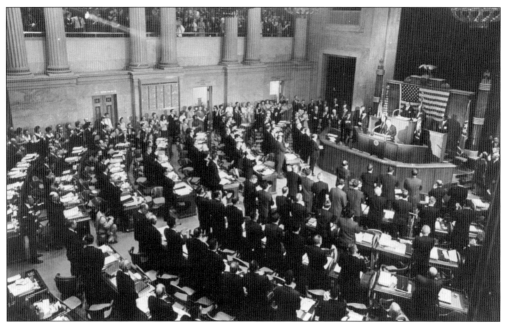

In 1967, the Tennessee General Assembly invited Pres. Lyndon B. Johnson and the First Lady, Lady Bird Johnson, to Nashville to commemorate the 200th anniversary of Pres. Andrew Jackson's birth. Here, the room applauds as the president delivers his address. Johnson used this speech to gather support for his hard-line policy in Vietnam and increase military pressure. Lady Bird Johnson and Governor Ellington can be seen to the right of the rostrum. (Courtesy of the Tennessee State Library and Archives.)

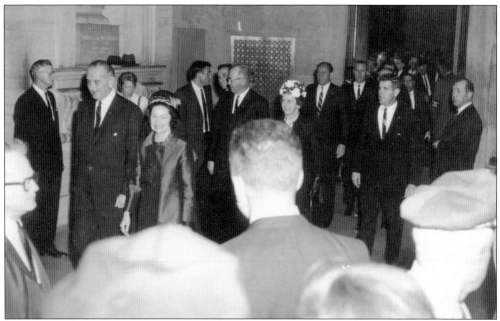

Here, President Johnson and the First Lady leave the House Chamber. While in Nashville, the presidential entourage had lunch with the governor at the capitol and toured the Hermitage. (Courtesy of the Tennessee State Library and Archives.)

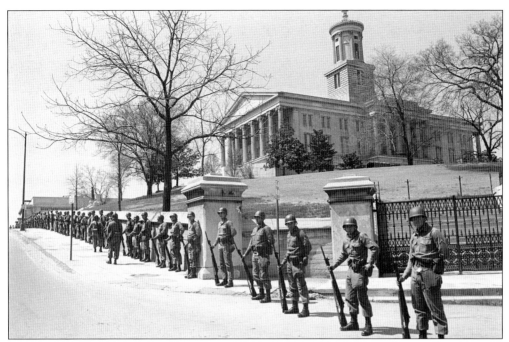
In the wake of Dr. Martin Luther King Jr.'s assassination, National Guardsmen were deployed to Capitol Hill as a precautionary measure on April 6, 1968. (Courtesy of the Nashville Public Library, Special Collections.)

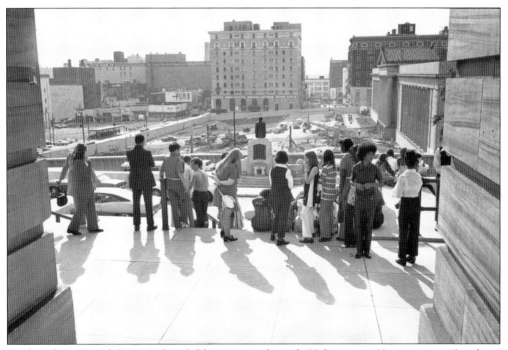
Students have visited the capitol on field trips since the early 20th century. Here, a group of students looks over the construction of the War Memorial Plaza in 1971. (Courtesy of the Nashville Public Library, Special Collections.)

Not only is the capitol Tennessee's seat of government, it has also become a popular tourist attraction. In recent years, a tour program has been established to meet the demand of thousands of tourists who visit from around the world. Here, Gov. Winfield Dunn poses with a group of college student tour guides who worked during the summer of 1973. Today, professionally trained educators from the Tennessee State Museum serve as ambassadors for the visitors. (Courtesy of the Nashville Public Library, Special Collections.)

Schoolchildren have visited the capitol to learn about their state government for generations. This group poses with Lt. Gov. Frank Gorrell on the south steps. Even today, this area remains a very popular spot for school pictures. (Courtesy of the Tennessee State Library and Archives.)

The capitol has doubled as a movie set several times throughout the late 20th century. Here, filming occurs in the second-floor rotunda on the set of the Disney film *Love Leads the Way*. Directed by Oscar-winning director and Nashvillian Delbert Mann, *Love Leads the Way* featured the story of Morris Frank, his seeing-eye dog Buddy, and the establishment of the seeing-eye dog program in America. The film premiered on October 7, 1984. (Courtesy of the Tennessee State Museum.)

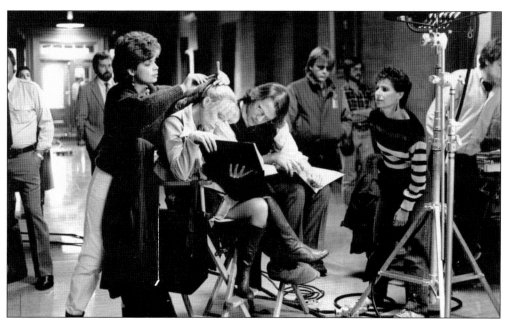

Actor Sissy Spacek studies her script on the first floor of the capitol during the filming of *Marie: A True Story*. In this 1985 film, Marie Ragghianti, played by Spacek, challenges a system of corruption during Gov. Ray Blanton's administration in which prison paroles were being traded for bribes. (Courtesy of the Tennessee State Museum.)

Generations have gathered at the capitol to make their voices heard. Here, demonstrators protest the unveiling of the bronze bust of Nathan Bedford Forrest in November 1978. Members of First Baptist Church Capitol Hill, Gordon Memorial United Methodist Church, and the NAACP organized the demonstration. (Courtesy of the Nashville Public Library, Special Collections.)

A choir sings on the east steps of the capitol for a Homecoming '86 picnic. Homecoming '86 was a yearlong statewide effort to promote the history and culture of Tennessee's communities. Over 800 communities participated in activities that included a traveling musical production called *Comin' Home to Tennessee*, storytelling events, and school educational programs that focused on state pride. (Courtesy of the Tennessee State Library and Archives.)

This image documents perhaps the most Tennessee governors ever to be photographed together. Taken in the Old State Supreme Court Chamber after the election of Gov. Bill Haslam in November 2010, it includes six governors. From left to right are Lamar Alexander (1979–1987), Don Sundquist (1995–2003), Phil Bredesen (2003–2011), Bill Haslam (2011–2019), Ned McWherter (1987–1995), and Winfield Dunn (1971–1975). (Courtesy of the Tennessee State Museum.)

Discover Thousands of Local History Books Featuring Millions of Vintage Images

Arcadia Publishing, the leading local history publisher in the United States, is committed to making history accessible and meaningful through publishing books that celebrate and preserve the heritage of America's people and places.

Find more books like this at
www.arcadiapublishing.com

Search for your hometown history, your old stomping grounds, and even your favorite sports team.

Consistent with our mission to preserve history on a local level, this book was printed in South Carolina on American-made paper and manufactured entirely in the United States. Products carrying the accredited Forest Stewardship Council (FSC) label are printed on 100 percent FSC-certified paper.